# THE ART OF
# Bridal Portrait Photography

Techniques for

Lighting and

Posing

Marty Seefer,
M. Photog. Cr.

AMHERST MEDIA, INC. ■ BUFFALO, NY

## DEDICATION

Dedicated to Stella P. Seefer, my wife, my soul mate, the mother of my son, my best friend and the "Wind Beneath My Wings."

Without her support, love and confidence stretching, my abilities would not be what they are.

Copyright © 2002 by Marty Seefer

All photographs by the author.

All rights reserved.

Published by:
Amherst Media, Inc.
P.O. Box 586
Buffalo, N.Y. 14226
Fax: 716-874-4508
www.AmherstMedia.com

Publisher: Craig Alesse
Senior Editor/Production Manager: Michelle Perkins
Assistant Editor: Barbara A. Lynch-Johnt
Editorial Assistant: Donna Longenecker

ISBN: 1-58428-067-0
Library of Congress Card Catalog Number: 2001 132040

Printed in Korea.
10  9  8  7  6  5  4  3  2  1

# TABLE OF CONTENTS

# Acknowledgments

IN EVERY LIFE, THERE ARE PEOPLE WHO make indelible impressions. My life is filled with such people. I've always believed that I am a reflection of all those who have had affected me. In my adult life, I've always chosen to be surrounded by positive thinking people. My teachers are all of those whom I have come in contact with. Some have affected me more than others, but all have left their impression.

My greatest teachers were my parents and to them I owe the most—my life.

My wife, Stella, has stood with me through thick and thin and her love, support and confidence have given me the courage to flourish and grow as an individual.

Our son, Carl, who is no longer physically with us, taught me how to love unconditionally and to look at others with eyes searching for their intangible positivity.

The magic of photography is a vision from G–d. I cherish that gift and believe that my purpose on Earth is to capture and share the vision and happiness that I see for posterity. Many friends have had a role in helping me to cultivate that gift. Bill and Rachel Stockwell showed me the excitement of photography. Vince Thomas taught me to see light. Don Blair demonstrated the physical, full-length posing that I do to this day. Monte Zucker taught me how to use light and "the pose" together. Dean Collins taught me lighting relationships through "the seeing" and "the manipulation" of light.

Kris Wolff, my physical trainer, not only taught me about my physical potential, but she had the patience to be photographed as an integral part of the explanation of this book in "My Studio Lighting Diagram."

We have met many friends both in the photographic field and in our personal life. Many times these relationships have no boundaries. Our friends stood with us when times were the most difficult and we can't thank them enough. Dick Robertson was

the first to recognize my talent and he went that extra step in fostering me as a beginning photographer. He took me under his wing and helped me to use my gift. The members of Connecticut Professional Photographers Association gave me the support and knowledge to help me cultivate my talent.

Lenzart Color Lab, located in Buffalo, New York, is our portrait lab. They are fantastic—we have had a wonderful relationship with them for the past eighteen years. We thank them from the bottom of our hearts for the retouching and printing of all the color portraits found in this book.

All of our clients have been very supportive and their high standards have encouraged me to grow.

I want to thank my publisher, Amherst Media, particularly Michelle Perkins, for her incredible patience.

Stella and I are a very lucky couple, having been surrounded by so many wonderful, giving people whose support and encouragement have defined us. There are two photographers who have been especially influential in our lives for many years and, for a multitude of reasons, have given me spiritual love and support. They are Chris and Pat Beltrami. I am extremely thankful that they have written the forward to this book.

# FOREWORD

THE FIRST TIME WE WITNESSED MARTY Seefer photographing, we were amazed at the methodically precise way that he approached his assignment. The very first thing he did was to pull out this wonderfully folded piece of cloth and clean not only the outside optics of the lens but the inside element also. He commented that he did this for every assignment.

"Imagine that!" we thought. It certainly made sense. Most photographers we knew would clean their lenses twice a year—if they remembered.

So, when we heard that Marty was writing a book on bridal photography, our initial reaction was "Oh boy!!! This is going to be good!" Marty Seefer won't begin something if he cannot do it superlatively.

The second thought that came to our minds was that Stella (Marty's wife) wouldn't be seeing a lot of her husband until the book was completed. And, with Marty's persistence toward excellence and his attention to detail, this was going to take a long time.

As we hold the final draft of his work in our hands, we are amazed at the amount of hours that were spent to complete it. You can quickly see this book represents a labor of love—each page radiates a great feeling of precision and exactness.

Marty begins by teaching basic principles in a manner that is very easy to understand. He initiates his individual studies with head & shoulder, $^3/_4$- and full-length bridal portraits. After that, he continues through an array of individual bridal portrait studies that include studio, on location, outdoors, high key, low key, profiles and more. He teaches, thoroughly and excitingly, how to use flash, reflectors, gobos, natural light, props, archways, double archways, mirrors and more.

Every portrait page contains a short note about the unique aspects of the particular portrait and—what we like

best—a very helpful summary of the lighting relationships.

This book is for everyone. Whether you are a beginner or a seasoned pro, you will be able to improve your skills, discover new ideas and to enter the "Satin Jungle" with renewed artistic passion.

First, you should read this in its entirety—as a marvelous bridal photography workshop—savoring every thought and idea. After that, you should keep the book in a place where it can be viewed spontaneously and often, maybe when you're running a bit dry and need a reawakening.

So, have fun reading this book and learning a bunch of good stuff.

And to Marty and Stella, our very good friends, as Danny DeVito telephoned his wife at the end of the movie *War of the Roses*, "Love ya, Miss ya, Want ya!!!"

**Chris and Pat Beltrami**
*M. Photog., Cr., F-ASP*

# INTRODUCTION

**B**ASICALLY, I AM A PERSON WHO LIKES people. The real enjoyment of photography is the personal interaction of being with others. On a surface level, we as portrait photographers capture the person in their best light, hiding the flaws and capitalizing on their outstanding characteristics. On a deeper level, I am attracted to the idea that, even given all of our knowledge of lighting and skills in posing people, our *real* gift is the ability to learn what makes our subjects come alive on paper.

### ● PORTRAITIST VS. JOURNALIST

There are two basic categories of portrait/ wedding photographers: the journalist and the portraitist. In my mind, the journalist has a very important responsibility in documenting and taking exposures that make statements about what the subject is doing in the environment, and as he or she relates to others and nature. The journalist makes his/her statement without personally interacting with the subject and produces a "fly on the wall" or "slice of life" that quantifies existence. Generally, this photographer is reactive.

As a portrait photographer, I interact with my clients and a piece of me is part of every photograph I make. I try to idealize

> I AM PROUD TO BE
> A PROACTIVE PHOTOGRAPHER.

my subjects. I am proud to be a proactive photographer. As I pose the bride, I want to make her look as regal as a queen. I want wonderful posture and everything that can bend, should. The expression on my subject's face is the most important, however. At the time of exposure, I want my subject to be distracted from the camera. Whether the bride is looking at me or off into the distance with "hope in her eyes," I want her to show real emotion.

I find it very important to previsualize the moment of exposure. As I speak to my client, either in the camera room or in the conference room, I observe the little things she does that are unique to her. The little dimple that exaggerates when she smiles, the tiny squint of her nose, and the cute tip of the head. It is my responsibility to trigger those reactions and document her emotions with my visualizations under optimal conditions in the camera room.

As a portrait artist, previsualization also means that I need to utilize the tools I have for corrective lighting. The shape of her face, the size of her nose, the relative height to weight relationship and the type of lighting source that I need to use are all considerations for successful portraiture.

It is also my responsibility to show dimension. Photography is a two-dimensional art form that begs to depict three dimensions. Lighting is key. Understanding each light's purpose and versatility is paramount to the successful fulfillment of your idealized vision. In the pages that follow, diagrams and photographs will explain what I do.

● LEARNING EVERY DAY

I learn every day when I engage a client and use my camera. I people-watch and observe behavior even when my camera is at rest and in its case. My goal in writing this book is to impart so many of the things my wonderful teachers have presented to me. It is my hope that you too will use your gifts to the best of your ability.

● CONSISTENT METHODS

For consistency of habit, I try to maintain the same work habits wherever I'm shooting. In general, all of my portrait work (either in the studio or on location) is done on tripod. I've also built a little cart that houses all of my equipment including filters, lights, gels and lenses, cameras and backup equipment. It is on wheels and has baskets on the shelves. It all goes with me on location.

---

## I OBSERVE THE LITTLE THINGS SHE DOES THAT ARE UNIQUE TO HER.

---

Early in my career, I had electrical wires and PC cords all over the floor. In my excitement, they would be invitations to trip. Now, whether in my camera room or at someone's house, I use a radio control (General Variances) and never have to worry about having a PC cord long enough. Also, this is very helpful during wedding receptions when dealing with amateur photographers.

I have also learned that Velcro® and PVC piping can be very good friends. I use them both frequently.

My favorite f/stop is f/8.5. I like the depth of field, and the color saturation is optimal. Speaking of color saturation, my exposures are generally one stop over what

the labs say is normal. This produces the color saturation that I want with hues that are strong and tones that are vibrant.

I use $1/30$ of a second for most of my shutter speeds. I want the flash on my cam-

THIS PRODUCES THE COLOR

SATURATION THAT I WANT.

era (the fill light) to illuminate the scene, the off-camera flash (main light) to illuminate the subject, and the shutter speed to allow the ambient light to make the scene look natural. An exposure at $1/30$ of a second does this.

Many photographers are reluctant to use slow shutter speeds because they are concerned about movement blurring the portrait. However, the subject is illuminated only by the flash, which has a duration of only $1/10{,}000$ of a second. Therefore, the action is frozen, even though the shutter speed is relatively slow. This technique is called dragging the shutter and helps to eliminate the unnaturally dark backgrounds often found in wedding photography.

Whenever I photograph portraits, I also use a tripod and cable release to eliminate camera movement.

CHAPTER TWO

# METERING THE EXPOSURE

MANY PHOTOGRAPHERS ARE UNDER THE impression that the negative films we use have a five-stop latitude. This is simply not true! On the chart below, if f/8 is our aperture setting on the camera, two f-stops below (reflective f/4) will render black with detail and three above (reflective f/22) will render white with detail.

In my portraits, I try to ensure that all areas with important detail fall within a range of two stops below and two stops above my aperture setting. Doing so will insure the negative will have a full range of tones in the final print.

In each of the lighting diagrams that are illustrated in the pages to come, notice the "lighting relationships" section, usually found at the top of the page. This will demonstrate the relationship between the main light and each of the other lights used in the presented image.

● FILM TESTS

We need to be as precise on the exposure as we are capable of being. My system of metering depends on the fact that I test my film before using it on our paying clientele. After performing my tests, I look for the

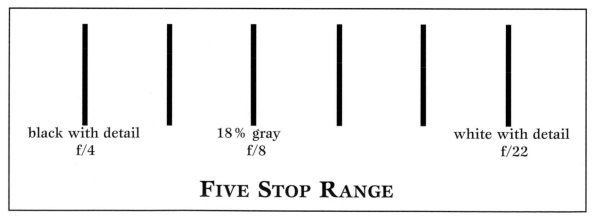

black with detail
f/4

18% gray
f/8

white with detail
f/22

**FIVE STOP RANGE**

best saturation, details in the highlights and details in the shadows. My rationale is based on metering the highlights, and setting my exposure for these bright areas, rather than the shadows. A two stop exposure difference above the aperture's setting will register white with detail, while a two stops difference beneath the aperture's setting will register as black with detail. Many times, we look at the negative and see different gradations not represented on the print. This is because these tones are out of the printing range for the paper.

● METERING

All metering is based on an 18% gray value, for this is all that any meter "sees." One of my favorite instructors, Dean Collins, shared with a class an interesting story about how 18% gray came to be the standard. It's actually an average. He said that if 10,000 photographs were taken—amateur, professional, scenic, journalistic, fine art, portrait, wedding and commercial (actually any type, whether on negative film or transparency, color or black and white), and if each of those 8" x 10" images were then cut up into one inch squares, and each of those square inches were metered, the average of all of these millions of pieces of photographic medium would be 18% gray.

There are two types of metering for exposure: incident readings and reflected readings.

Reflected readings measure the amount of light bouncing off the subject—its lumi-

nosity. All through-the-lens meters (those built into cameras) are reflected meters. What your camera len's meter "sees" is 18% gray. The reading it provides is therefore designed to render that tone as 18% gray on your film. However, what you put in front of your camera's lens might *not* be 18% gray (say, a white wedding gown). Unfortunately, the meter doesn't know this, so it will still provide a reading that will render that tone as 18% gray on your film.

As you can see, averaging can sometimes be skewed. For example, have you ever taken a photograph with bright snow? Snow is white, not 18% gray. If you make

*To make a reflected reading, I take the flat dome off and point the meter toward the background. This gives me a relationship based on 18% gray that I can compare to any of the other lights I use.*

the exposure suggested by your reflected meter (without compensation), you would underexpose the snow by three stops, making it 18% gray on your film. The result will be a weak image that will be almost impossible to print as white.

If you put an 18% gray object (or a gray card) in front of your through-the-lens metering system in your camera, and take your reading off this, then your exposure will be correct each time. Unfortunately, this is not always possible.

Let's look at the example of photographing snow again. This time, we'll use the incident meter. Unlike a reflected meter, an incident meter measures the amount of light that falls onto the subject. Portrait professionals and commercial photographers usually choose this type.

In the image below, notice where the meter is placed. Understanding that the meter still sees only 18% gray, I aim the meter toward the light source—be it a reflector, the sun, or a flash inside a soft box. Metering the main light directly in front of my subject and aiming the meter at my light source tells me my aperture setting.

When using multiple light sources, I aim the meter toward each light source in turn. This tells me the relationship of each light

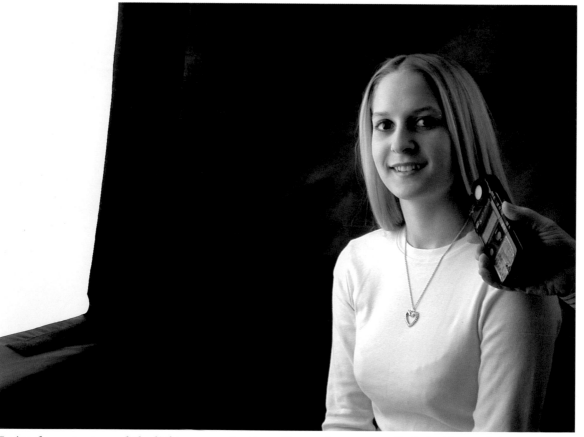

*I aim the meter toward the light source—be it a reflector, the sun or a flash inside a soft box. Metering directly in front of my subject and aiming the meter at my light source tells me my aperture setting.*

source to the other(s). For this procedure, I use a flat dome on the meter to isolate each light source. Aiming the flat dome at the main light tells me what aperture the camera should be set to.

● METERING FOR CONSISTENCY

Now that we know what incident meters can do (namely, see 18% gray), we need to learn how to use them consistently in order to achieve repeatable results. I've always believed that photography is a combination of art and science. It is predictable and repeatable. So often, when I began my career, I'd see a photo I had made and tried to duplicate the results. Generally, I was unsuccessful because I had no idea what I had done in the first place. Without consistency, we are left groping in the dark—no pun intended.

The following sections will deal with making sure that the film's 18% gray is the same 18% gray that the meter is seeing, and the same 18% gray that the lab is producing. All equipment is different. Shutter speeds may differ in nanoseconds and each camera maker may have very slightly different calibrations. Our lenses might even have different calibrations from unit to unit.

Regardless of how wonderful a lab is, making a print requires a subjective point of view. The person video monitoring the negative and setting up a bar code for the printer is the person who is making the determination of how the final product will look. At a commercial lab, especially in the economy divisions, much of the process is even automated. Because of this, the professional photographer needs to do his or her part to determine what the print should look like.

## OUR VISION IS A CONTRIBUTING FACTOR IN OUR STYLE.

We do that by rating the film correctly and metering our exposures with consistency. By making sure that the meter, the lens and the film are all in synch, we are able to gain consistent results.

● FILM SPEED

The ISO suggested by the film manufacturer is only a suggestion! It is a starting point. We all see differently. Our vision is a contributing factor in our style. I happen to like a bolder saturation of warm color with a higher contrast than normal. Some photographers like a cool, pastel look to their work. My meter calibration makes it possible for me to predictably get the look I want.

● TRANSPARENCY VS. NEGATIVE FILM

Metering consistency is the backbone of making properly exposed negatives or transparencies. Besides the obvious (one creates positives, one creates negatives), the major difference between transparency and negative stock is that transparency film has very little exposure latitude. With transparency film, the highlights need to be exposed

exactly so that the range of tones can be captured as seen. Half an f-stop of over- or underexposure can have a great impact.

When using negative stock, it might appear that exposure precision is not nearly as critical—but it is. The flexibility in negative-produced prints stems from the reliability of the second generation image—the print. The lab (and here's that subjective aspect again) has the ability to print in several tracts for differences in films, or for

---

## COMMUNICATION

I've always believed that my lab, my camera, and my vision are partners in creating the best work I am capable of delivering to my clients. Just telling my lab to develop, print and mount denies the basic premise of quality. Communication is a major key to receiving fine work when dealing with any color lab. As I mentioned before, I like bold colors and warm tones. Some photographers like cool tones and pastel colors. It all depends upon your taste and vision. Exposure controls many things, and your metering and communication with your lab manager is essential. The idea is to eliminate subjective judgments by the lab. When you control the highlights and shadows, all that is left for the lab to do is color balance. When you send examples of your work in different situations, all they have to do is duplicate your requests when making your prints.

---

over- and underexposure. That means the person doing your printing has a lot of control over your final outcome. If you want to

---

## THE PERSON DOING YOUR PRINTING HAS A LOT OF CONTROL.

---

retain more of that control, the steps on pages 17–21 can be followed to make your meter and your film "see" the same 18% gray.

### ● ELIMINATING SUBJECTIVE JUDGMENTS

Transparency film is rated for the highlights and, historically, negative film has been exposed according to the slogan "Expose for the shadows and print for the highlights." What this means is we are overexposing the film with little rhyme or reason. While the expression really does make sense, it was based on single sheets of film being exposed and developed, not on today's roll film.

If, on the other hand, we *expose* our film for the highlights and *print* for the highlights, we are telling the lab person exactly what we want based upon our metering. By defining the highlights, we are also telling the lab what we want the shadows to look like—regardless of the type of lighting (scrim, parabolic, soft box, window light), or the lighting situation (be it direct sun, open shade, off camera lighting, a main light with reflector, or a main light with fill light). With this system, we can eliminate subjective judgments by the lab.

Each time I begin to use a new type of film, I test it thoroughly. The images used in this chapter include a past test of VPS. I have purposely used this test because VPS is not produced anymore—I want you, a critical photographer, to do your *own* tests with your *own* equipment to come up with your *own* results for your *own* consistency. There are many easier ways to test your exposures, but this way has the benefit of being totally dependent upon your personal likes and dislikes in viewing images. It will determine, in part, your shooting style.

Whether you use a system of a main light with a reflector, or a main light with a fill light, metering for the highlights is (in my opinion) the most consistent way to get properly exposed negatives. If this is the way it works best for transparencies, for which exposure must be very precise, why would you use a less precise or different method when photographing on negative stock?

To get started, you must establish your metering technique. However you decide to use your incident meter, you must do so the *same way* every time you take a reading. Here are two possible methods:

**1.** *Stand at the subject and point the half dome toward the camera.* I do not practice this method for several reasons. First, I want to avoid averaged readings. When working outdoors with the half dome pointed toward the camera, part of the dome is getting exposure from the sky. This can throw off the exposure by as much as a full f-stop. I prefer to read each light independently, and the highlights together.

**2.** *Stand at your subject and point a flat dome toward the light source.* Using this method, you get a reading from the highlight side of the subject. This is the method I use consistently, regardless of my subject (tabletop photography or a bride) and regardless of the type of film I am using (transparency, negative or Polaroid).

## TO GET STARTED, YOU MUST ESTABLISH YOUR METERING TECHNIQUE.

Remember not to point the flat dome toward the light, but hold it parallel to the plane of the subject (in portraiture, the face). For instance, if I am outside in direct sun, I take the highlight reading of the amount of light falling onto the subject. To do this, I want my meter's dome to be parallel to the plane of the face and not aimed upward at the sun. If I aimed my meter upward, my image would end up being underexposed. In addition, I would actually be reading the subject's forehead, not the area from the chin to the hairline.

Once you have established your consistent method for metering, you are ready to begin your film test. Here are the steps you need to follow:

**1.** *Get two models.* Use one model with porcelain white skin and one with deep black skin. The light-skinned model should

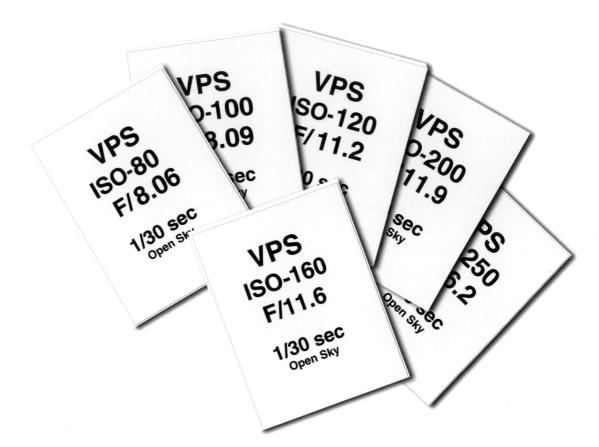

*Identification cards show the film, ISO rating, lighting situation and exposure. These cards are included in each frame of the test.*

wear a solid black shirt and the dark-skinned person should wear a white shirt.

**2.** *Add a gray card and identification sheet.* For my own film tests, I built a support from PVC that can be included in each frame. On the PVC, I hung an 18% gray card and an identification card showing the film and ISO rating.

**3.** *Determine the situations in which you photograph the most often.* Choose common lighting situations. I usually choose:

- on-camera flash
- low key with fill
- low key scrim with reflector

- open sky
- window light
- direct sun
- high key

**4.** *Make cards with the manufacturers' recommended ISO ratings as a starting point.* Then, bracket at various f-stops based upon your incident meter. Included on each card should be the following:

- the film tested (VPS in this case)
- the shutter speed (used to determine the middle exposure)

- the ISO used (and later reused to manipulate the exposure)

For example, when I tested VPS using open sky, I wanted my middle exposure (my starting point) to be ISO 160 (the manufacturer's recommended ISO). I chose the shutter speed that would give me a middle exposure point (somewhere between f/8 and f/11). My rationale for bracketing dictated that I would be changing the ISOs to change my exposures and compensating with my f-stops. In this case, my shutter speed was $^{1}/_{30}$ second and remained at this throughout all the exposures for open sky.

**5.** *Take readings and calculate exposures based on ISO manipulations.* (Do not start making exposures until you have all the information on your cards.)

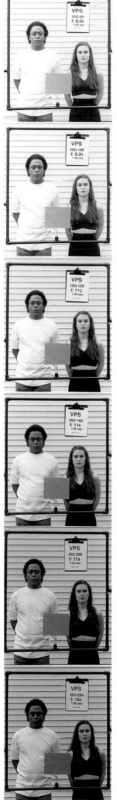

*Film test strips made in open sky.*

a. My meter exposure was set at the manufacturer's recommended ISO. In this case it was ISO 160. I wrote the f-stop, the middle exposure aperture (f/11.6) and shutter speed ($^{1}/_{30}$ second) on my card.

b. I changed my ISO to 120 and recorded that f-stop (f/11.2).

c. I changed the ISO to 100 and recorded that f/stop (f/8.09).

d. I changed the ISO to 80 and recorded that f/stop (f/8.06).

e. I changed the ISO to 200 and recorded that f/stop (f/11.9).

f. Finally, I changed the ISO to 250 and recorded that f/stop (f/16.2).

Once all of the cards were filled out and put in order, I mounted them on a clip board and set my shutter speed and camera's aperture to parallel the settings on each card. as I made each exposure.

**6.** *Talk to the lab manager.* After I finished shooting, and before I sent in the film, I spoke to the lab manager and told him what I was doing. It is very important that you speak to them first—before you send them the film! Tell the manager at your lab these three things:

**a.** Do not cut the paper or film (keep them in roll form).

**b.** Do not change the color densities.

**c.** Print based on your "Shirley."

Each day, the lab balances all of their equipment based upon a card called a "Shirley." That calibration is what is responsible for the lab's consistency. By having them print based on their "Shirley" (a known, constant value) we are trying to eliminate all bias of video analyzing.

Most labs will help you along with this test and some may even do it at no charge. All labs want you to be a consistent shooter. It will mean less time for them and fewer arbitrary decisions they will have to make.

**7.** *Evalute film and proofs.* You've now received your uncut film and proofs. Examine each lighting situation test separately. Do each category separately. Look for the frame in each situation that has detail in

*Each day, the lab balances all of their equipment based upon a card called a "Shirley." This type of testing and calibration is responsible for the lab's consistency.*

*Tear sheets of various lighting situations.*

the blacks and detail in the whites. Keep the proof strip uncut and view it in the area where you would view your clients' images. As you look for the correct exposure, eliminate the frames that have no detail in the highlights or shadows. This should leave approximately three images.

Now, look for the image that has the best saturation in the faces. (If you like pastels in your work, you'd be looking for a frame much different than the one that I would be looking for.) Choose the frame with the ISO that best represents the way you want your work to look. Do not consider color balance. Look only at the detail in the blacks and whites. For example, I want my white shirt to look white, and for both models to have detail in their faces. Also, look at the 18% gray card in the frame and see how closely it approximates the density of the 18% used in the actual test.

Once you have determined the best frame, use that same ISO when shooting in that same lighting situation. What you have

actually accomplished here is to synch your meter, camera and lens to your own lab's equipment (and "Shirley"). All of the equipment will be seeing the same 18% gray. Now that's communication!

**8.** After determining the appropriate ISO for each lighting situation, make a reminder sheet (I place mine on the meter).

**9.** For those of us who use medium format cameras, note that each glassine has vue meter numbers (a densitometer reading that measures the density of a negative when the film is analyzed) and exposure readings. After doing this procedure, you might note that, according to the lab, you are consistently $1–1^1/_2$ stops over. That's okay, because that is the exposure that you have chosen to produce the results you want.

On the glassine or back of the proof, you should continue to monitor your results for each negative when you get a roll of proofing back from the lab.

In some scenes there are multiple planes to be considered when making exposure decisions. In this bridal portrait, for example, there are five planes of exposure. All of these planes were metered using an incident meter with the flat dome aimed toward the light source. The shutter speed was determined by the candelabra's length of exposure ($^1/_2$ second) to ensure that an even amount of light would cover the first plane. The aperture on the camera was set to the subject's incident reading of f/11.

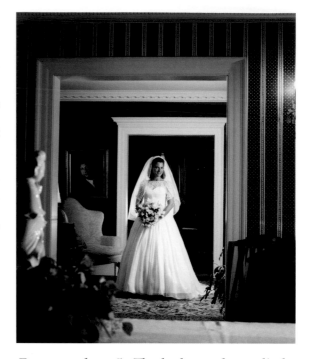

*Exposure plane 5: The background was lit by a window. The incident reading was f/5.6 at $^1/_2$ second.*

*Exposure plane 4: The second archway was lit by the main light and rimmed on the bottom by the separation light. The incident reading was f/8.5.*

*Exposure plane 3: The subject was lit by the main light. The incident reading was f/11.*

*Exposure plane 2: The first archway was lit by the candelabra. The incident reading was f/5.6.5 at $^1/_2$ second. This $^1/_2$ second determined the shutter speed.*

*Exposure plane 1: The statue was lit by the Vivitar 283. The incident reading was f/8.*

WINDOW

SEPARATION LIGHT

MAIN LIGHT

ACCENT LIGHT

# THE BRIDAL STUDY

THERE ARE MANY OPINIONS REGARDING the studio bridal session, and factors vary from bride to bride. History tells us that almost all brides had studio portraits done in their gowns. However, many brides and grooms never had even the candid wedding coverage usually offered today. In those days, equipment was not nearly as portable and many photographers felt much more comfortable in their studios, where the light was consistent and predictable.

● BENEFITS OF A STUDIO SESSION

Even today, there are many benefits to having the bridal session done before the wedding. One very obvious plus is that the portrait can be displayed at the reception. A second reason is that the bride can get to know her photographer.

A third benefit, and one that is easy to overlook, is that it lets the bride become more comfortable with her gown. Each time we have had a studio bridal session—and

there have been many—the bride has discovered that she didn't feel comfortable in her gown after wearing it for an extended length of time. Remember, this is generally

---

## THE PORTRAIT CAN BE ON DISPLAY AT THE RECEPTION.

---

the first time she will have worn it for longer than the time required for her fittings. So, in its role as a dress rehearsal alone, it makes good sense to have this session done.

In the camera room, we are able to utilize many unique backgrounds and nine different lights to illuminate the gown's texture. We create a number of beautiful views of the dress, including:

- full length
- three-quarter length
- head and shoulders from the front

- head and shoulders from the side
- head and shoulders from the back with the bride in profile

Because of this variety, we are able to get more detail and show the fine attributes of the gown. More importantly, we can capture the emotion on the bride's face and make her look the best she can. After all, her bridal portrait is one of the ways her grandchildren will remember her.

### LOCATION PORTRAITS

On location, we are limited to only four lights: the fill, the main, the background light and maybe an accent light. We do not bring a boom for the hair light—a very important light for the bride.

This type of bridal study session can be done on a day other than the wedding. One definite benefit of the location portrait is that the backgrounds involved will be meaningful to the bride. Whether it is the house where she grew up, her backyard, or a park—all are more meaningful to her than a studio backdrop. However, as photographers in these situations, we need to be very careful to reduce background distractions.

### SCHEDULING

Our studio prides itself on personal attention. When we schedule a pre-wedding bridal study, we book no other appointments for the day. We want the bride to feel unhurried and treated like a person of nobility. Because of this policy, we are able to spend much more time with her, trying a wider variety of poses and doing more refinements than we could possibly do on the day of the wedding.

### PREPARATION

For pre-wedding portrait sessions, the bride will need to make arrangements to pick up her dress. She will need to have it pressed, and bring it back to the salon for repressing before the wedding. If the session is used for dress-rehearsal purposes, she will also need to make the appropriate hair and makeup appointments.

## WE CAN CAPTURE THE EMOTION ON THE BRIDE'S FACE.

Flowers are always something of a dilemma. Although we have several beautiful silk bouquets, none will compare to the one on the day of the wedding. Ours will not be a duplicate of her own—it won't even have the same flowers or design style. With all of this in mind, the bride must decide whether she wishes to spend the extra money to duplicate her own flowers, or to settle for what is available.

On page 26, you'll find a bridal study suggestion sheet. This is what we give to brides to help them prepare for the session.

### WEDDING DAY PORTRAITS

On the day of the wedding, there are no additional plans to make (or costs to cover)

for hair, flowers or makeup. This is a benefit for many. Still, there's a big drawback to contend with—we have "Father Time" telling to us it's time to get to the church! Besides which, with so many people milling about the house (or dressing room) as the bride gets ready, the distractions can become an overload.

Another issue is the simple fact that this is the bride's wedding day. Does she really want to spend it posing for two hours?

Finally, the bonds that are made with the photographer and bride on pre-wedding day sessions are an intangible plus. In my mind, that chemistry is very important to making the wedding day flow smoothly. Scheduling the bridal portrait for the wedding day removes that benefit.

## COLOR VS. BLACK AND WHITE

As I mentioned at the beginning of this chapter, bridal studio sessions historically comprised the majority of the photographer's wedding coverage. During those years, black and white portraiture was the only option available.

Later, during the "baby boomer" years, color became the choice of most wedding couples. Now, when the generation following the "boomers" wants to enjoy their parents' wedding photos, they find that they are faded and discolored. For the most part, this is due to the unperfected color technologies of the past. While this is no longer an issue (the longevity of color film is at least 99 years), it is at least partially responsible for sparking renewed interest in archival quality black and white prints. For photographers, this popular interest offers additional creative opportunities. While color does provide a more natural look at the world, my personal choice for bridal portraits is the purity and richness of black and white. There are many reasons for this.

First, as a photographer, it's my responsibility to perform all black and white darkroom work. Because I do the printing myself, I can previsualize exactly how I want the finished portrait to look at the time it is taken. I have the capacity to make sure it looks that way throughout the entire process. That is a degree of control I do not have when our color lab makes the print—regardless of how carefully I expose my film or how talented they are.

I also believe that black and white is more dramatic, and that color can actually distract from the stateliness and timelessness of a portrait. In color portraits, the emotion can sometimes be overlooked. For me, the real essence of a bride is better revealed when she is photographed in black and white.

# BRIDAL STUDY SUGGESTION SHEET

Your bridal study can and should be used as a "dry run" for getting ready on the day of your wedding. This means that you should bring all the garments and undergarments you'll be wearing, get your hair styled, apply makeup, wear jewelry and bring flowers just as if it were your wedding day.

## STARTING FROM THE TOP

Your hair and makeup should be done at your home by the same person who will be doing it on the day of your wedding—but bring your makeup along for any necessary touchups.

Your gown and undergarments (nylons, bra, slip) should be those you will wear on the day of your wedding. Your dress should be completely altered and pressed. Once pressed, *do not* bustle the gown—leave it loose. This will insure that it will not get wrinkled. Once you get the gown home, hang it from the highest point you can find (even the top of a door) so that it remains fresh and unwrinkled. Lay a blanket underneath the gown on the floor and arrange the train on it.

You should bring with you all jewelry that will be worn—including your wedding band (if available), earrings, necklaces and bracelets.

You should bring the bouquet if your flowers are silk. If you are using fresh flowers on the day of your wedding, you can ask your florist to duplicate the bouquet (if authenticity is important to you). Otherwise, you may choose to use one of our silk bouquets.

If you would like to have a "before and after" photograph, bring a nice robe with you. Also, do not have your headpiece put on prior to the session, but plan on putting it on at the studio.

## EXPECT TO BE PAMPERED

A bridal study is both emotionally and physically draining for the bride. For that reason, we suggest that your appointment be made during the time of the day that you are at your best and freshest. You should eat before arriving at the studio and allow approximately $1^1/_2$–2 hours for the session.

We have a selection of music that we play during the bridal study to "set the mood." However, we encourage you to bring your favorite music—that will both relax you and get you into a "regal" mood.

# STUDIO LIGHTING

On PAGE 28 IS A DIAGRAM OF MY CAMERA room. I use nine lights, all flashes with modeling lights. Two are not shown in this diagram, since I use them only for high key portraits against pure white backgrounds. We will discuss this type of portrait at a later time. A third light is also not shown: the separation light. It will be discussed below. How many lights are used in the session is determined by the look I want and by my client's patience. For instance, if I want to show a great deal of roundness and depth I will use more lights. If I am photographing a child I will use fewer lights.

The purpose of each light and its relationship to the others is discussed on the following pages. The diagram on page 28 shows these lights, their effects, and the combination effect with other lights.

● LIGHTS BETWEEN THE SUBJECT AND THE CAMERA

*Main Light or Key Light (Contrast and Direction).* This light shows roundness and contrast from highlight to shadow. It is the source of light ratio (see page 30). In the system of light measurement that I use, the main light is my starting point. I set the aperture on my camera to the incident reading of my main light. I generally like my meter reading for the main light to be f/8,

I USE NINE LIGHTS, ALL FLASHES

WITH MODELING LIGHTS.

f/8.5 or f/11. From my testing, I find that I get the depth of field I desire and the best color saturation at these settings.

*Fill Light (Directionless and Shadowless).* The fill light is used to lighten the shadows created by the main light and add to the roundness of the subject's appearance. This light is behind the camera, it provides no direction of light and casts no shadow. Note the difference between the fill light and the main light images in the diagram.

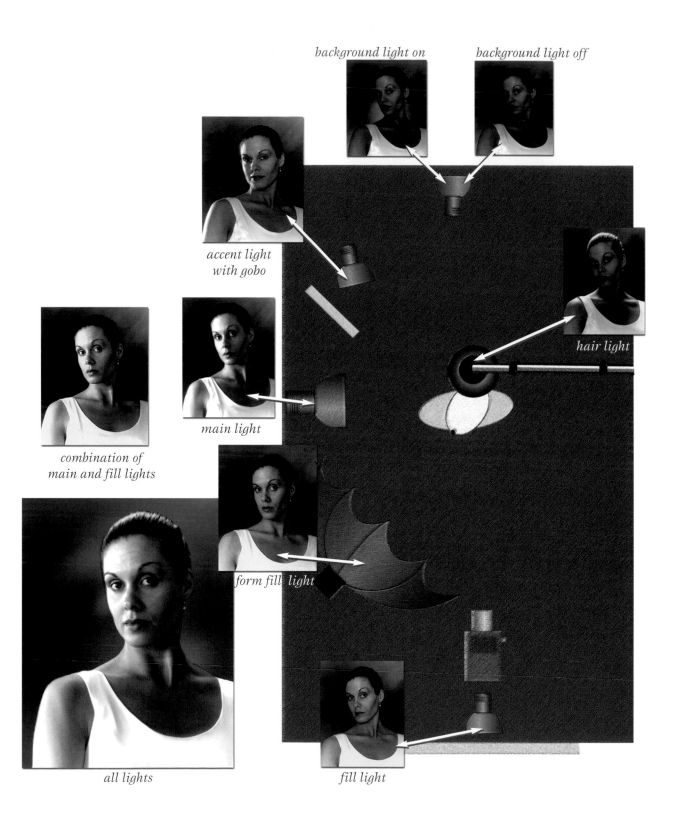

background light on

background light off

accent light
with gobo

hair light

combination of
main and fill lights

main light

form fill light

all lights

fill light

The fill light is usually a large light source, such as an umbrella with no specularity or a white wall. I often use a White Lightning 1200 with the silver ring attached and bounced into a 4' x 8' white Styrofoam board. In other cases, I also like to use a reflector to fill the shadow side of the face.

There are different schools of thought regarding the rating of the fill light. Some say that the incident reading of your fill light should be what your aperture is set at. Others believe that the main light's incident reading is what your aperture should be set at. Since I meter for the highlights, my starting point when metering is my main light. I then adjust the fill light so that it is 1–1.5 stops less than my main light. Whatever method you choose, be consistent.

*Form Fill Light.* This is a light that follows the nose, lighting only the mask of the face. For form fill, I use a light source that is large (such as a 40" umbrella or a soft box), but not as large as the fill light. In the diagram on page 28, note the differences between the effects of the fill light, the form fill and the main light. Also, compare each light with the image that shows the combination of the main and form fill.

● LIGHTS BETWEEN THE SUBJECT AND THE BACKGROUND

*Hair Light.* This light, placed over the subject, illuminates the hair and adds texture to it. It also separates the hair from the background. My hair light is a White Lightning 1200 encased in a self-made 6" x 18" foam-core soft box with rip stop nylon placed over it for light diffusion. It is suspended from the ceiling. If a person has dark black or brown hair, its incident reading is usually set two stops above the main light. If the subject has blond or white hair, the hair light is usually equal to the incident reading of the main light (or .5 stop less). If the person is bald or has very thin hair, I do not use the hair light at all, since this emphasizes what the person is likely to consider one of their less attractive features.

## WHATEVER METHOD YOU CHOOSE, BE CONSISTENT.

*Background Light.* This light illuminates the background. In studio situations, my background light is either a ceiling-suspended White Lightning 1200 or a Lumedyne on the floor. I use the Lumedyne light both in the studio and on location when I want to avoid having a cord on the floor.

The background light is probably the one light that contributes most to the successful depiction of three dimensions. It is also the light that is overused most often. Used properly, the background light should simply create the illusion that there is a space of some kind between the subject and the background.

I usually use a reflected reading to set this light 1.5–2 stops lower than my main light. In the lighting diagram, notice the

slight difference with the background light on and off. With the light off, it looks like the subject fades into the background.

*Accent Light or Kicker Light.* The kicker or accent light is a light that skims the highlight side of the subject and creates additional roundness and range of tone. It has an additive effect with the main light and the aperture on the camera needs to reflect compensation. For instance, imagine a situation where the main light has an incident reading of f/11, and the accent light has an incident reading of f/8. F/8 is half the intensity of f/11, so we add one half an f/stop to the main light to change the aperture to f/11.5.

Note that the kicker light is usually angled to skim the face. Therefore, it is aimed at the lens and can cause a desaturation if the light from it enters the lens directly. A gobo, or light blocker, is generally placed between the light and the lens to prevent the light from striking the lens and fogging the film.

*Separation Light.* This light is not shown on the composite. Please refer to studio sessions 1 and 2 (pages 37 and 39) to see the effects of the separation light. Its sole purpose is to light the back of the hair, veil or dress, creating a halo effect or separating the subject from the background. It differs slightly from the background light because it is aimed at the subject rather than the background. Like the hair light or background light, a little goes a long way.

In the diagrams below and on the facing page, you'll see the ratio of the fill light to the main light. Imagine taking any unit of measurement—be it a cup, quart, foot or pound. In the illustration of one to one (1:1) lighting, notice that one part (your unit of measurement) is applied to each side of the face. In this illustration it is

ONE TO ONE LIGHTING

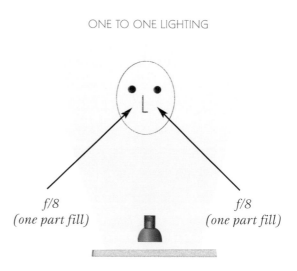

f/8
*(one part fill)*

f/8
*(one part fill)*

f/8. If we were to take an incident reading of each side of the face as shown, both sides would read f/8. The lighting is very flat and doesn't show the shape of the woman's face.

In two to one (2:1) lighting, we have set up a different ratio. The fill is still delivering one part to each side of the face at f/8. But we now add the main light to our ratio. If the main light is also f/8 (the same intensi-

ty as the fill), then we will be adding an *additional* one part of light to the left side of the face, as shown in the diagram. Notice we now have a directional quality to the light. Our image has more roundness than in the first image. On the right side of the face, we have one part of light and on the left side of the face we have two parts of light.

TWO TO ONE LIGHTING

f/8
*(one part
main light)*

f/8
*(one part fill)*

f/8
*(one part fill)*

THREE TO ONE LIGHTING

f/11
*(two parts
main light)*

f/8
*(one part fill)*

f/8
*(one part fill)*

Now here is where some people get confused with lighting ratios—with three to one (3:1) lighting. The fill is still the same (f/8) as shown in the one to one diagram on page 30. This means that the right side of the face, the shadow side, is still getting only one part of light from the fill. To make the light more contrasty than in the image of

## BE CAREFUL NOT TO BRING THE REFLECTOR TOO CLOSE TO THE SUBJECT.

two to one lighting, we will double the intensity of light on the main light either by increasing the power or moving it closer to the subject. This means we will need to make the main light read f/11. Since f/11 is twice as much light as f/8, the highlight side will now be receiving three parts of light (two from the main light and one from the fill).

*Metering for Ratio Lighting.* After I read each of the lights individually, I read these lights (the frontal lights) together. This reading is the f/stop to which I set my aperture.

If I am using only a main light with a reflector, the aperture will be set at whatever the main light reads. The shadow side of the face is fine-tuned visually by moving the reflector or changing the type of material it is made from. For example, silver has high reflectivity, while shiny white creates softer shadows.

Be careful not to bring the reflector too close to the subject. This can eliminate dimension and cause the subject to look flat—as in one to one lighting.

# PORTRAIT SESSIONS

IN THE FOLLOWING SECTIONS, YOU WILL FIND portraits paired with descriptive diagrams and text. The diagram depicts the actual lighting setup with all of the lights used shown in their correct position. I have also included the rationale for choosing each setup for the particular image, how I arrived at my settings and the relationship between the lights involved. The purpose of the lighting relationships is to illustrate that my incident meter reading of the subject's face is my starting point and relative to the other lights. Note the box labeled "Lighting Relationships" on each page to see the difference in light intensity relative to the main light.

In chapter 5, "Studio Sessions," you will see the various props, poses and typical lighting setups that I use.

In chapter 6, "Location Sessions," you'll see portraits that required me to work outside of my past habits and choose a different way of thinking. For selected images, I have included information on my thought processes—from previsualization to the final outcome. I have detailed the changes made so that the final image lived up to my vision.

In chapter 7, "Showing Support," you will learn how I add grooms, ring bearers and flower girls to brides' portraits. Options for lighting and posing these group portraits are also discussed.

In chapter 8, "Special Lighting Techniques," you will find some interesting ways of using creative lighting techniques to enhance the flexibility and dramatic appeal of basic sets.

For each of these chapters, you may explore the images sequentially, or find images you particularly like and examine their creation one by one. You need not read sequentially.

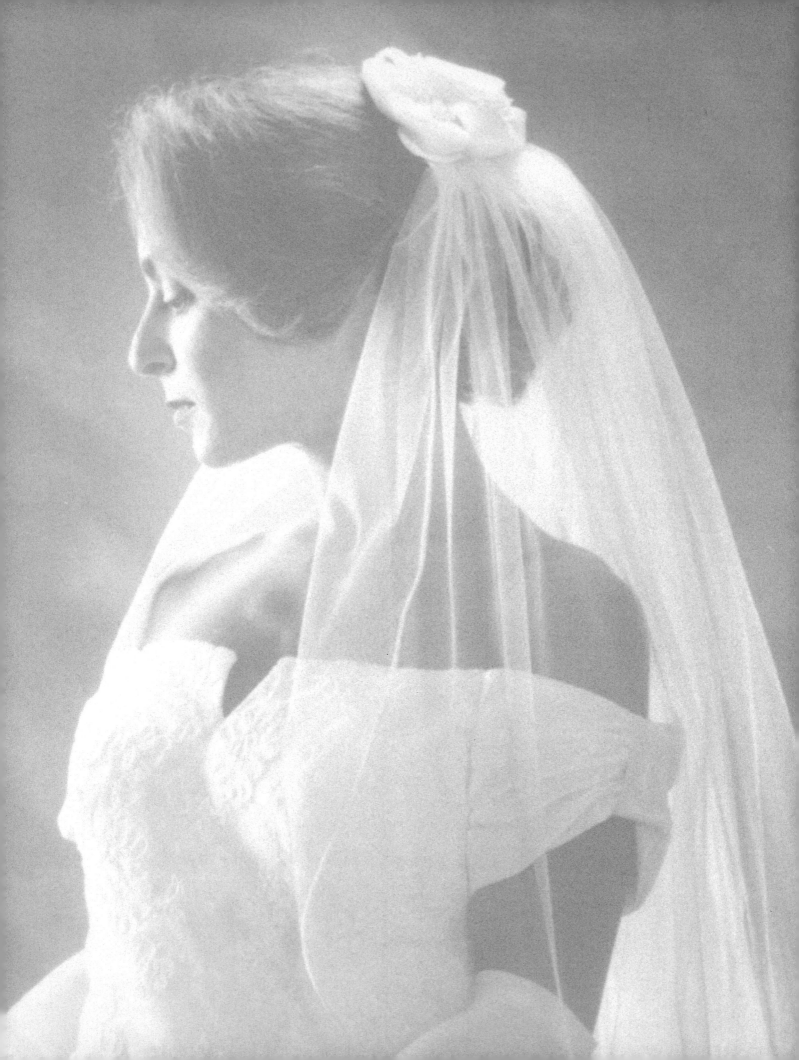

# 5

# STUDIO SESSIONS:

## TECHNIQUES AND IMAGES

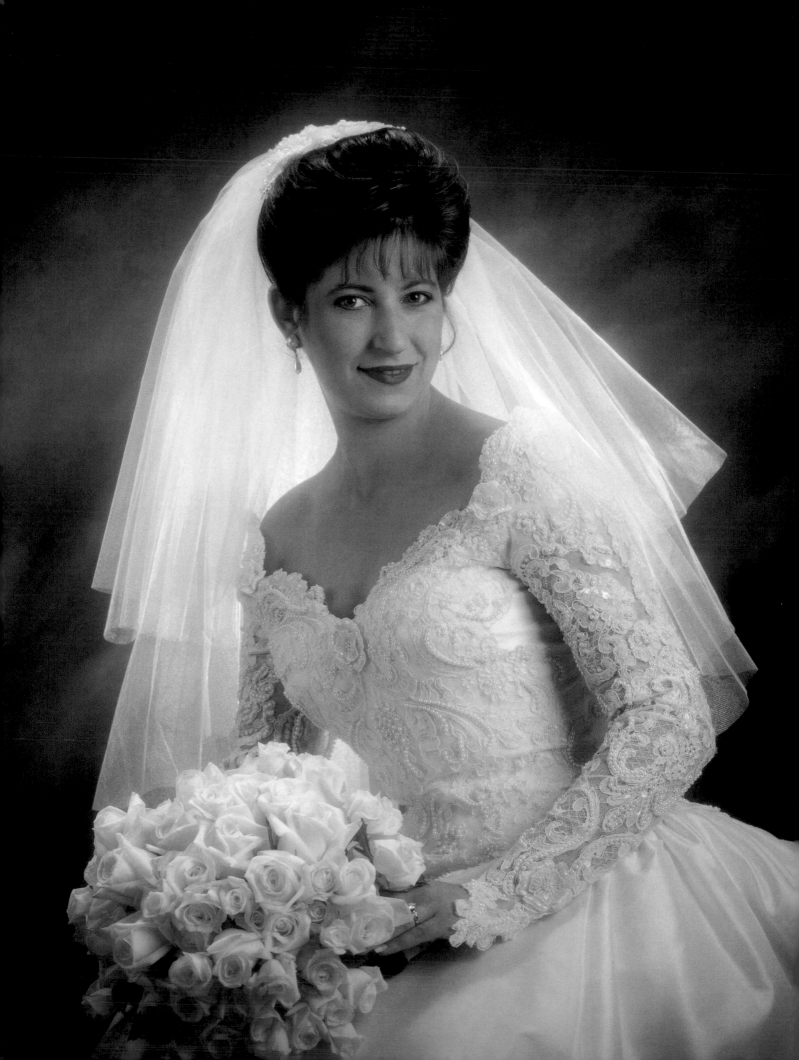

POSING

This image was selected to illustrate a 3/4 body position combined with a 2/3 facial position.

LIGHTING

Backlighting (see diagram below) was used to accent and frame the face, as well as to enhance the appearance of the veil.

COMPOSITION

The backlighting effect also contributes significantly to the composition of the image, defining the peak of the triangle.

---

**LIGHTING RELATIONSHIPS**

f/5.6.5— background light (-1.5 stops)

**f/11.0— main light separation light**

f/11.5— hair light (+.5 stop)

---

**BACKDROP**

**BACKGROUND LIGHT/SEPARATION LIGHT:** Lumedyne bare bulb placed vertically between subject and background. Background incident reading: f/5.6.5, separation reflected reading through veil: f/11.

**HAIR LIGHT:** White Lightning 1200 suspended from ceiling with 6" x 18" self-made foamcore soft box and white rip stop nylon (to diffuse light). Incident reading: f/11.5.

**SUBJECT**

**REFLECTOR:** Photogenic 36" x 48" super silver.

**MAIN LIGHT:** White Lightning 1200 in Chimera 36" x 48" soft box. Incident reading: f/11.

**CAMERA:** Mamiya RZ67 with 180mm lens. **APERTURE:** f/11. **SHUTTER SPEED:** 1/30 second. **FILM:** Kodak PRN ISO 100.

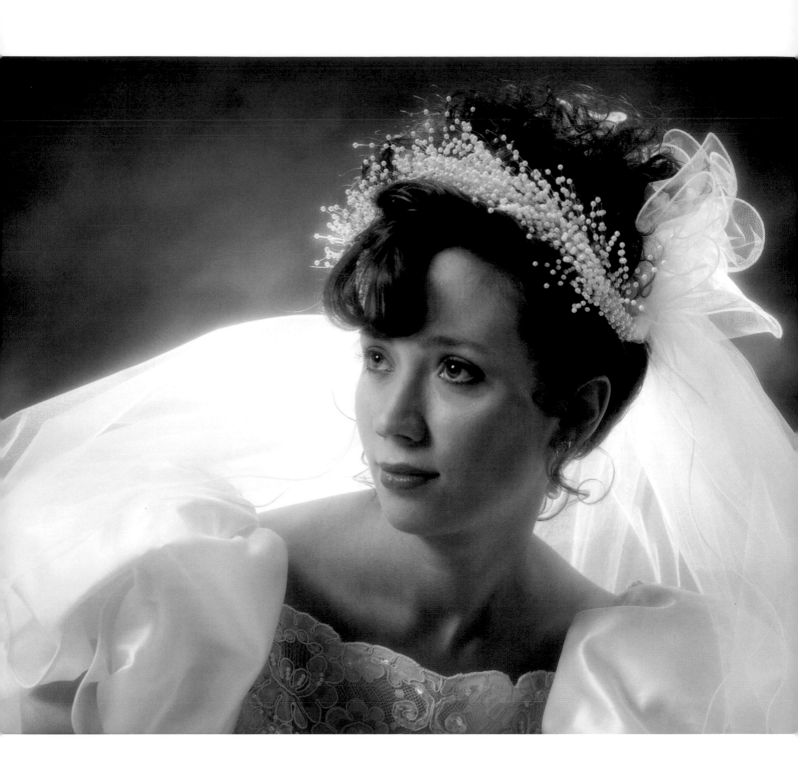

GOBO

The Photogenic reflector serves two purposes. First, it provides fill light to open up the shadows created by the main light. Second, it functions as a gobo, preventing light from flaring on the lens. This is important for retaining the desired color saturation.

POSING

The female body should look graceful and elegant—anything that can bend should. The head should be gently tipped toward the higher shoulder and the upper body should lean forward. Creating diagonals in posing adds impact to the composition.

### LIGHTING RELATIONSHIPS

| | |
|---|---|
| f/5.6.5— | background light (-1 stop) |
| f/8— | hair light (-.5 stop) |
| **f/8.5—** | **main light** |
| f/11.5— | separation light (+1 stop) |

**BACKGROUND LIGHT/SEPARATION LIGHT:** Lumedyne bare bulb placed vertically equidistant between subject and background. Background reflected reading: f/5.6.5, separation reflected reading through veil: f/11.5.

**BACKDROP**

**MAIN LIGHT:** White Lightning 1200 in recessed Chimera 36" x 48" soft box placed horizontally. Incident reading: f/8.5.

**SUBJECT**

**HAIR LIGHT:** White Lightning 1200 in self-made foamcore soft box covered with white rip stop nylon (to diffuse light). Incident reading: f/8.

**REFLECTOR:** Photogenic 36" x 48" super silver placed horizontally to kick light back up into the shadow side of the face.

**CAMERA:** Mamiya RZ67 with 250mm lens and Lindahl Compendium lens shade. A single layer of black stocking is placed over the lens for diffusion. **APERTURE:** f/8.5. **SHUTTER SPEED:** 1/30 second. **FILM:** Kodak VPS rated at ISO 80.

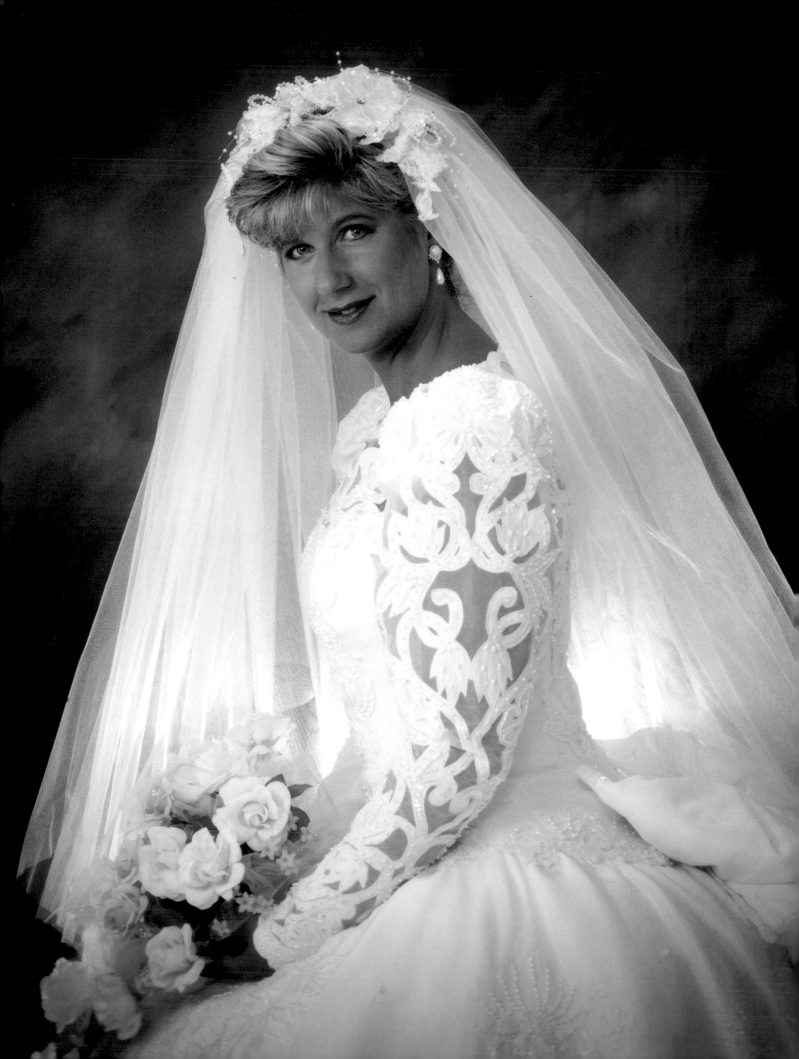

COMMON PROBLEMS

This image illustrates some common, simple problems that could be easily corrected. Note that the separation light at the bride's waist is very hot (bright). This could be corrected either by placing the separation light lower and feathering it up toward the veil, or placing it directly behind the bride's shoulder blade and lowering the power. The front shoulder is also very prominent—almost the size of the bride's head. As a result of this, little perspective is shown. This shoulder needs to be swivelled to her left, so that the right shoulder is visible and the body looks more properly balanced.

**BACKDROP**

**BACKGROUND LIGHT:** Ceiling-suspended White Lightning 1200. Reflected reading: f/5.6.

**SEPARATION LIGHT:** Lumedyne aimed at veil. See above for critique. Reflected reading through veil: f/11.5.

**HAIR LIGHT:** White Lightning 1200 in self-made foamcore soft box covered with white rip stop nylon (to diffuse light). Incident reading: f/8.

**MAIN LIGHT:** White Lightning 1200 in recessed Chimera 36" x 48" soft box placed vertically. Incident reading: f/11.

**SUBJECT**

**CAMERA:** Mamiya RZ67 with 180mm lens and Lindahl Compendium lens shade. **APERTURE:** f/11. **SHUTTER SPEED:** 1/30 second. **FILM:** Kodak PRN ISO 100.

**FILL LIGHT:** White Lightning 1200 with silver parabolic reflector bounced into a 4' x 8' white Styrofoam board. Incident reading f/5.6.6.

| LIGHTING RELATIONSHIPS | |
| --- | --- |
| f/5.6— | background light (-2 stops) |
| f/5.6.6— | fill light (-1.5 stops) |
| f/8.0— | hair light (-1 stop) |
| **f/11.0—** | **main light** |
| f/11.5— | separation light (+.5 stop) |

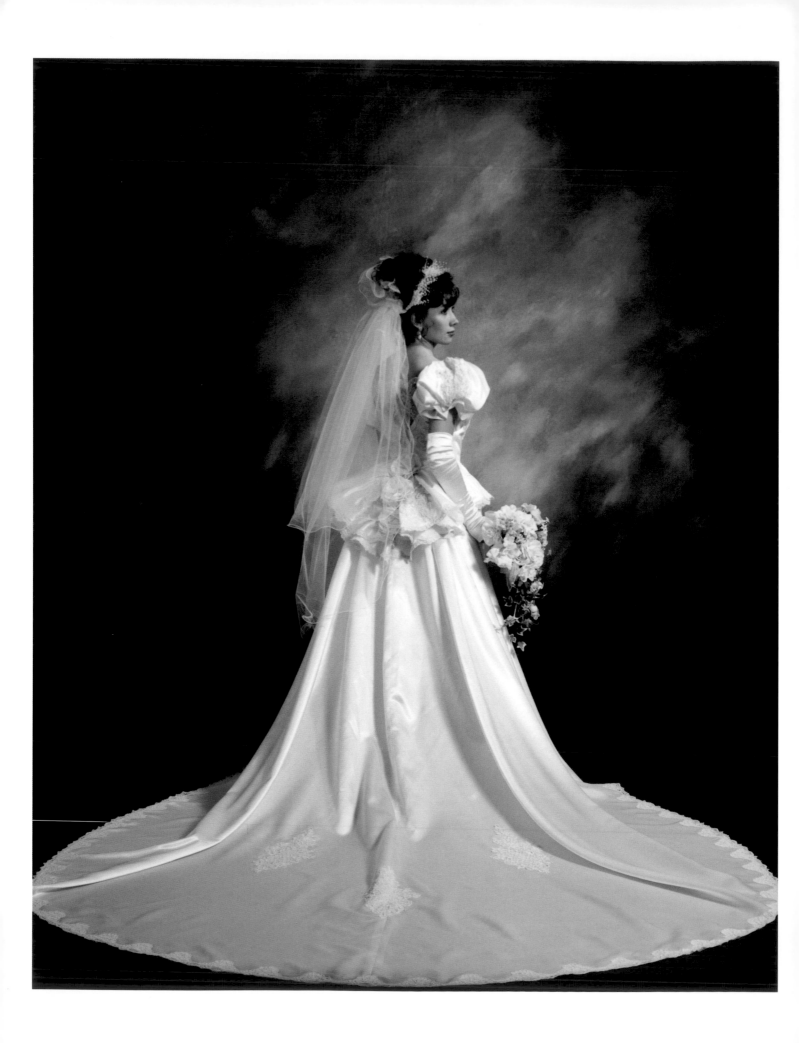

CAMERA ANGLE

This image demonstrates a full-length profile. It also demonstrates the effect of camera angle. In this case, the image could have been improved by placing the camera slightly higher.

This would place it in line with the subject plane, the imaginary line running from the top of the head to the nearest point of the gown. This would improve both the proportions and the depth of field.

LIGHTING RELATIONSHIPS

f/8.0— fill light (-1 stop), hair light (-1 stop), background light (-1 stop)

f/11.0— **main light**

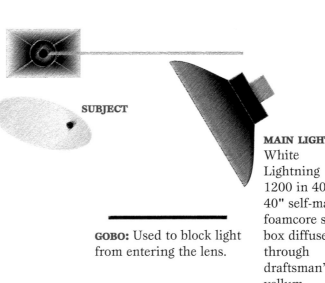

**BACKGROUND LIGHT/SEPARATION LIGHT:** Ceiling-mounted White Lightning 1200 with 20° grid to focus light. Reflected reading: f/8.

**HAIR LIGHT:** White Lightning 1200 in self-made foamcore soft box covered with white rip stop nylon (to diffuse light). Incident reading: f/8.

**BACKDROP**

**SUBJECT**

**MAIN LIGHT:** White Lightning 1200 in 40" x 40" self-made foamcore soft box diffused through draftsman's vellum. Incident reading: f/11.

**GOBO:** Used to block light from entering the lens.

**CAMERA:** Mamiya RZ67 with 90mm lens. **APERTURE:** f/11. **SHUTTER SPEED:** 1/30 second. **FILM:** Kodak VPS rated at ISO 80.

**FILL LIGHT:** White Lightning 1200 with silver parabolic reflector bounced into a 4' x 8' white Styrofoam board. Incident reading: f/8.

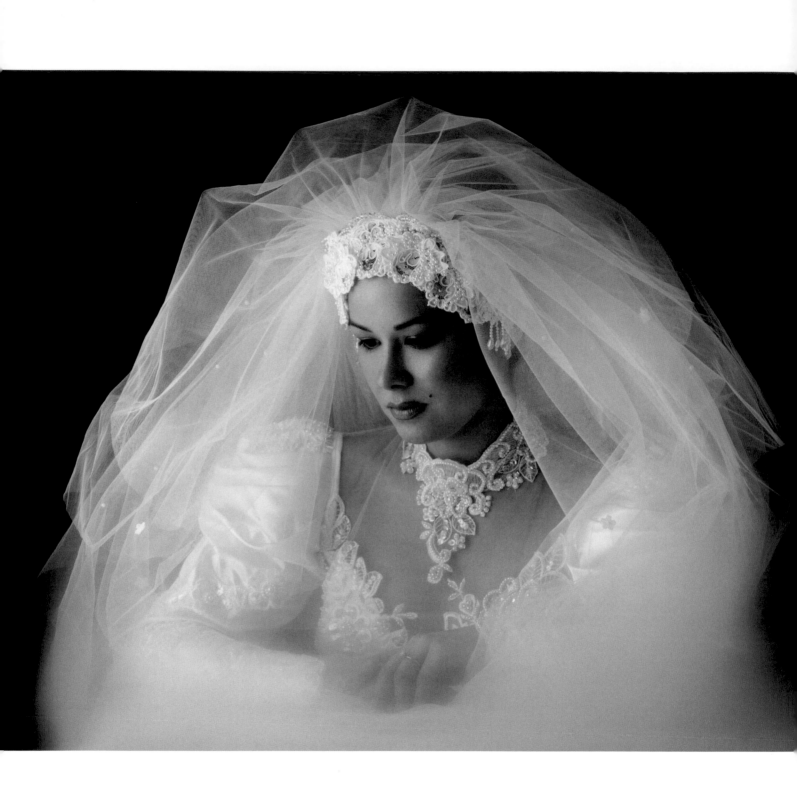

BACKLIGHTING

This image is another example of the nice effect you can achieve with back-lighting. Notice how well the veil is defined from the background. The back-ground is black only due to the careful attention to

ensure that no light fell on it (see notes below).

CAMERA ANGLE

The camera angle is slight-ly elevated, keeping the lens plane in line with sub-ject plane for the best rep-resentation of proportion.

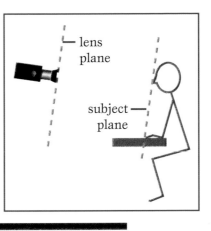

**SEPARATION LIGHT:** Lumedyne with silver parabolic reflector aimed just below shoulder level. Reflected reading through veil: f/5.6.5.

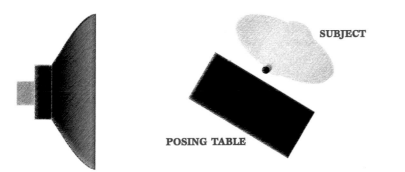

SUBJECT

POSING TABLE

**REFLECTOR:** Photogenic 36" x 48" super silver horizontally placed.

**MAIN LIGHT:** White Lightning 1200 in 36" x 36" self-made foamcore soft box with recessed edges. Soft box is aimed away from background slightly to avoid spilling light onto it. Light is diffused through drafts-man's vellum. Incident reading: f/11.

**CAMERA:** Mamiya RZ67 with 250mm lens. Lindahl Compendium lens shade has 4" x 4" glass smeared lightly at the bot-tom with petroleum jelly to create an ethereal effect. **APERTURE:** f/11. **SHUTTER SPEED:** 1/30 second. **FILM:** Kodak VPS rated at ISO 80.

LIGHTING RELATIONSHIPS

f/5.6.5—   separation light
                 (-1.5 stop)

f/11.0—   main light

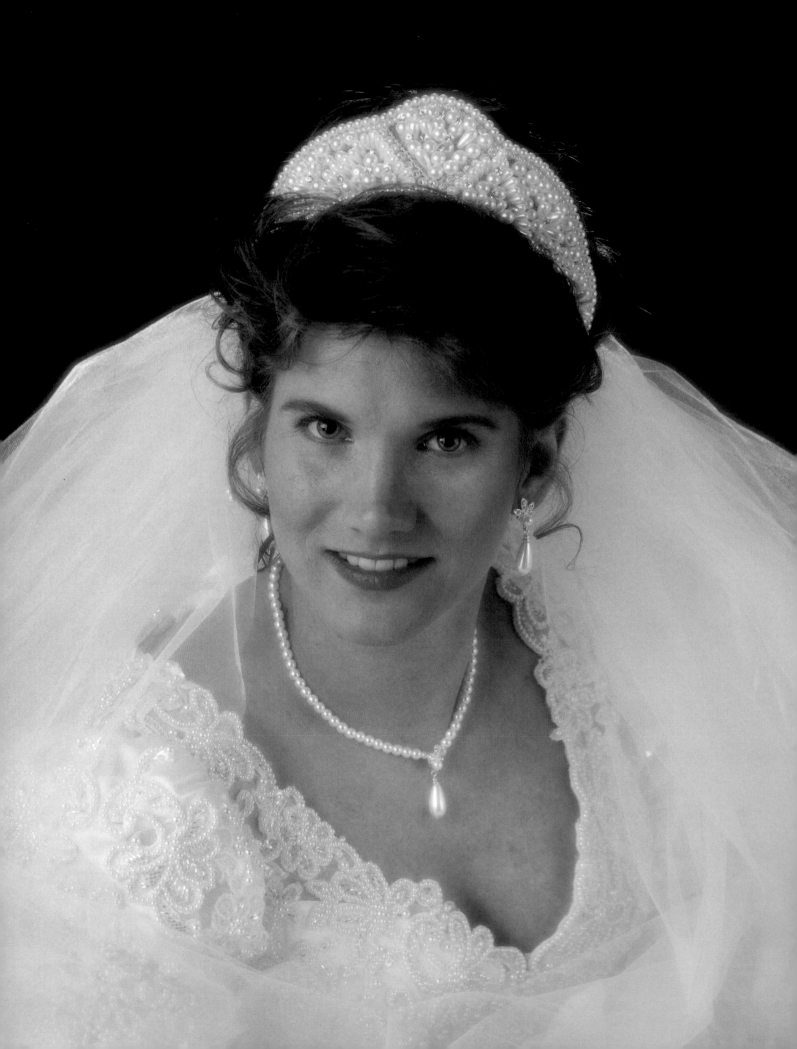

CATCHLIGHTS

Note the correct 11 o'clock positioning of the catchlights in this bride's eyes

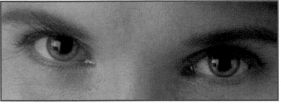

(enlarged view below). With the catchlights in this position you can be sure that the eyes are fully illuminated and will look alive and vibrant in the portrait.

POSITION OF MAIN LIGHT

Placing the soft box (main light) closer to the bride makes it larger in relation to the subject it is lighting. As a result, the shadows it creates on her face have very soft and flattering edges.

**SEPARATION LIGHT:** Lumedyne with silver parabolic reflector aimed just below shoulder level. Note the even tonality of the veil from left to right. Without the separation light the veil would be brighter on the main light side. Reflected reading through veil: f/8.

**HAIR LIGHT:** White Lightning 1200 in self-made foamcore soft box covered with white rip stop nylon (to diffuse light). Incident reading: f/8.5.

**SUBJECT**

**REFLECTOR:** Photogenic 36" x 48" super silver.

**MAIN LIGHT:** White Lightning 1200 in recessed Chimera 36" x 48" soft box, placed vertically. Incident reading: f/11.

**CAMERA:** Mamiya RZ67 with 180mm lens and Harrison #2 diffusion filter. **APERTURE:** f/11. **SHUTTER SPEED:** 1/30 second. **FILM:** Kodak PRN rated at ISO 100.

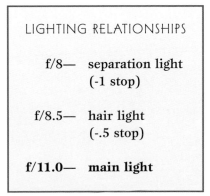

LIGHTING RELATIONSHIPS

f/8— separation light
(-1 stop)

f/8.5— hair light
(-.5 stop)

**f/11.0— main light**

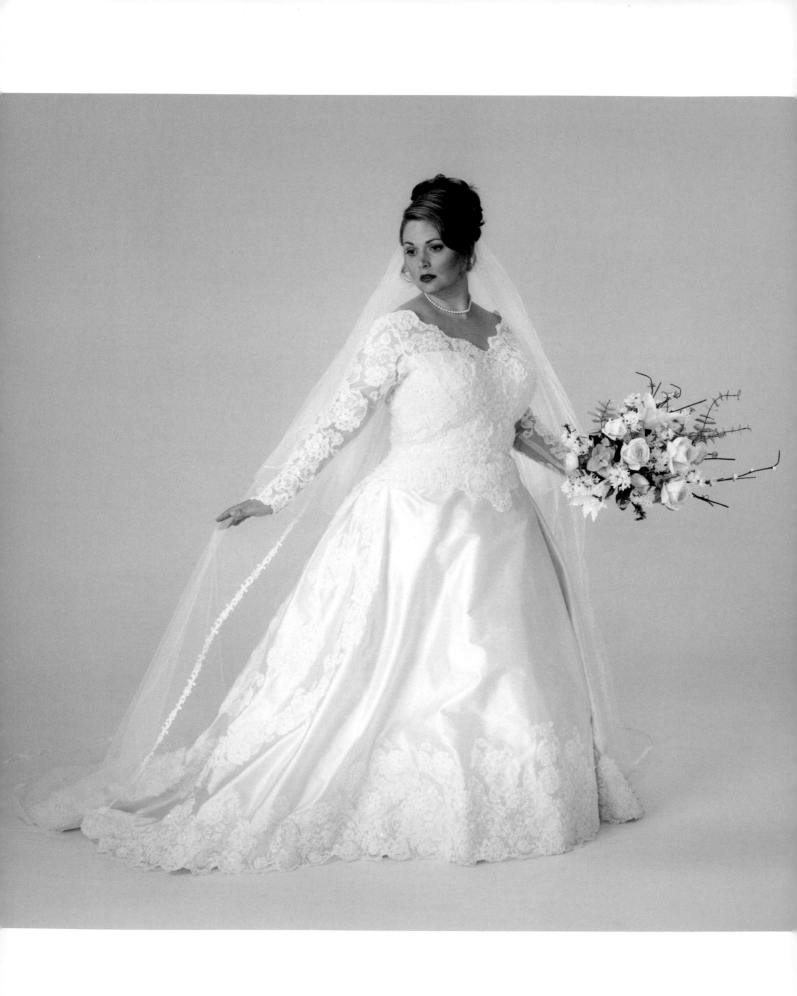

POSING

This portrait illustrates a flattering pose for the fuller-figure bride. The arms and flowers are posed gracefully away from the body, creating a slimmer, more streamlined look on the torso. The use of a medium-key setup and horizontal format also draw the viewer's attention to the bride's face, as it is the point of greatest contrast in the frame. The soft diagonal lines of the veil are also used to lead your eye to her face.

COVE CROSS SECTION

*wall supports*
*braces in wall supports*
*masonite*
*dampened sheet rock and smoothed spackle*
*floor*

**SEPARATION LIGHT:** Lumedyne with silver reflector and diffusion lid aimed at upper back. Reflected reading through veil: f/5.6.5.

**BACKGROUND:** White cove background (see cross section above) with no light applied. Reflected light reading: f/4.5.

SUBJECT

**HAIR LIGHT:** White Lightning 1200 in self-made foamcore soft box covered with white rip stop nylon (to diffuse light). Incident reading: f/8.

**REFLECTOR:** Photogenic 36" x 48" super silver, positioned vertically.

**MAIN LIGHT:** White Lightning 1200 in Chimera 36" x 48" soft box, placed vertically. Incident reading: f/11.

**CAMERA:** Mamiya RZ67 with 90mm lens. **APERTURE:** f/11. **SHUTTER SPEED:** 1/30 second. **FILM:** Kodak PRN ISO 100.

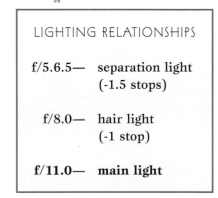

LIGHTING RELATIONSHIPS

f/5.6.5—  separation light (-1.5 stops)

f/8.0—  hair light (-1 stop)

f/11.0—  main light

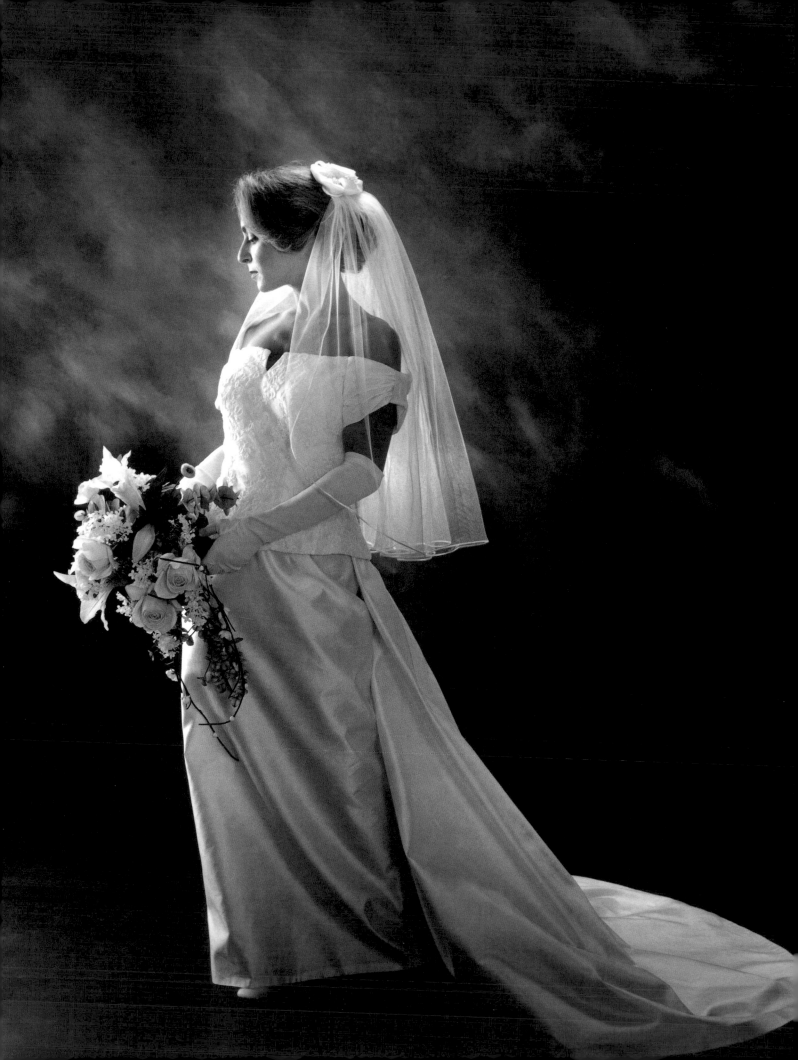

POSING

To correctly expose this image, I had to determine what part of the image should get the most attention. In this case, it was the mask of the face. To properly expose this area, all of the light that hit it had to be considered in proportion. Here, the subject's face was lit by three sources: the main light at f/11.5, the kicker light at f/8.0, and the fill light at f/5.6.5. The kicker light and fill light add about a full stop of illumination to that metered from the main light. I therefore exposed the face at f/16.5.

---

**LIGHTING RELATIONSHIPS**

f/5.6.5—  fill light
             (-2 stops)

  f/8.0—   separation light
             (-1.5 stops),
             kicker light
             (-1.5 stops)

f/11.5—  **main light**
             **hair light**

---

**KICKER LIGHT:** White Lightning 1200 with 20% grid. Incident reading: f/8.

**MAIN LIGHT:** White Lightning 1200 in 36" x 48" Chimera soft box, placed vertically. Incident reading f/11.5.

**SEPARATION LIGHT:** Lumedyne bare bulb aimed at subject's shoulder blades. Reflected reading through veil: f/8.

**HAIR LIGHT:** Ceiling-mounted White Lightning 1200 with 20% grid. Incident reading: f/11.5.

**SUBJECT**

**BLACK GOBO:** Used to prevent the kicker's light from flaring the lens and causing desaturation.

**CAMERA:** Mamiya RZ67 with 90mm lens. **APERTURE:** f/16.5. **SHUTTER SPEED:** 1/30 second. **FILM:** Kodak TMAX ISO 100.

**FILL LIGHT:** White Lightning 1200 bounced into white 4' x 8' Styrofoam board. Incident reading: f/5.6.5.

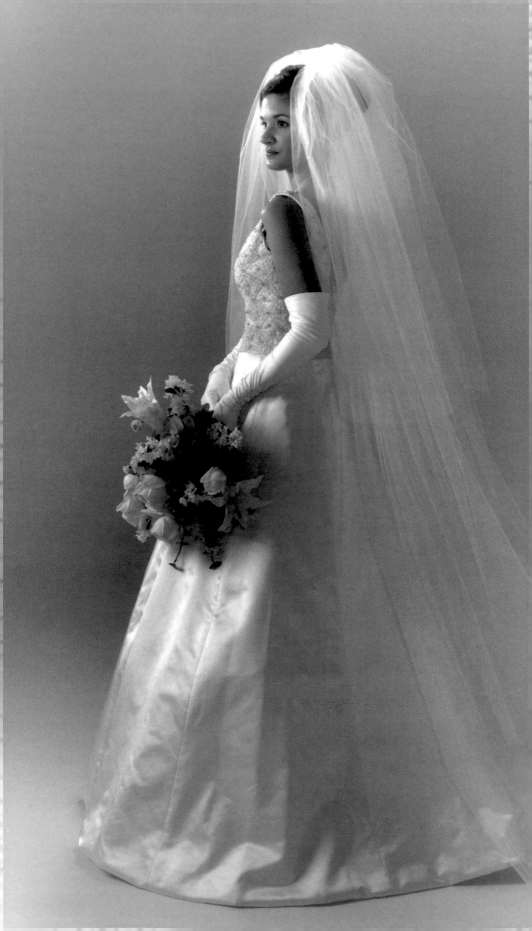

AMBIENT LIGHT

As you can see in the diagram below, no light source is applied directly toward the white background in this image. Ambient flash illuminates the background. Using a reflective meter, the background read three stops below the main light even though no light was directly applied to it.

---

LIGHTING RELATIONSHIPS

**f/11.5— main light**

**f/16.0— hair light**
**( + .5 stop)**

---

**WHITE BACKGROUND**

**MAIN LIGHT:** White Lightning 1200 in Chimera 36" x 48" recessed soft box. Incident reading: f/11.5.

**HAIR LIGHT:** White Lightning 1200 in self-made 16" x 18" foamcore soft box covered with white rip stop nylon (to diffuse light). Incident reading: f/16.

**SUBJECT**

**REFLECTOR:** Photogenic 36" x 48" super silver. Also acts as a gobo to shield the lens from possible flare from the main light.

**CAMERA:** Mamiya RZ67 with 90mm lens. **APERTURE:** f/11.5. **SHUTTER SPEED:** 1/30 second. **FILM:** Kodak TMAX ISO 100.

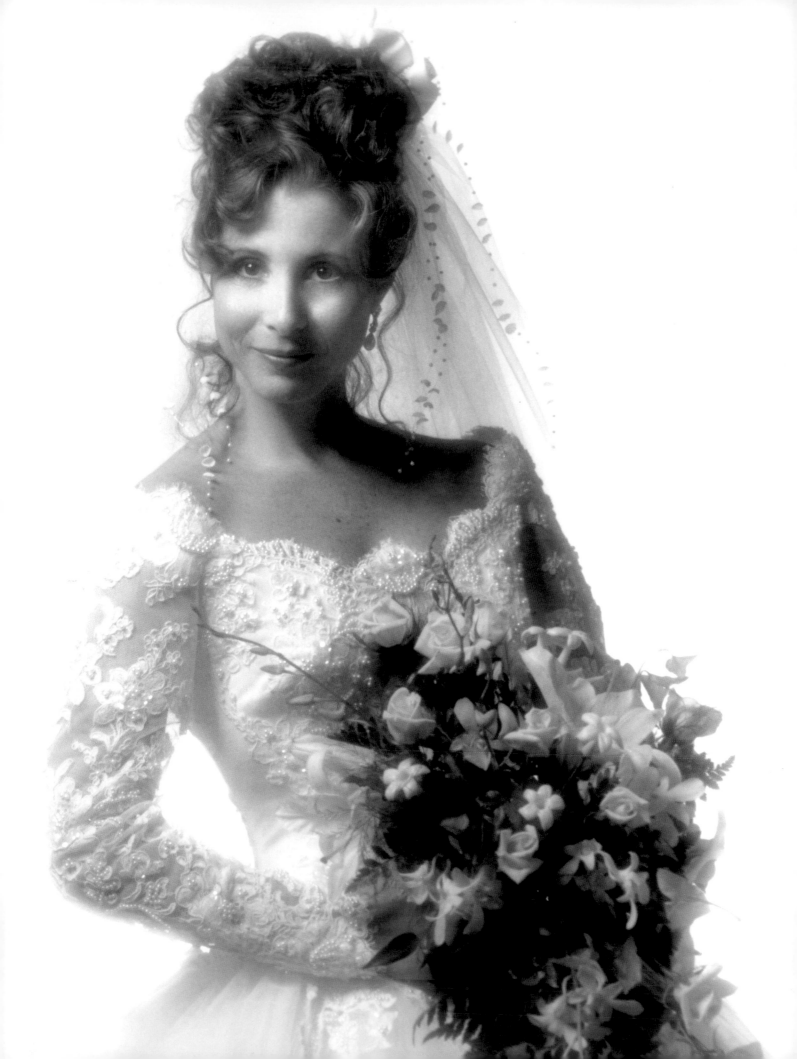

LIGHT RATIO

This image illustrates the dramatic effect that can be created using a high light ratio. This means that there is a relatively large difference in exposure between the highlight side of the face and the shadow side. Here the rather deep shadows on the right side of the bride's face were created by reducing the amount of fill light on this side. Since fill light was supplied by a reflector in this setup, all that was needed was to move the reflector back away from the subject.

LIGHTING RELATIONSHIPS

**f/11.0— main light**

f/22.0— background
light ( + 2 stops)

**BACKGROUND LIGHT:** Lumedyne with diffuser disc to spread light out, avoiding center hot spot. Reflected reading: f/22.

**MAIN LIGHT:** Larson 24" x 24" soft box with Photogenic Portamaster. Incident reading: f/11.

**SUBJECT**

**REFLECTOR:** Photogenic 36" x 48" super silver.

**CAMERA:** Hasselblad 500CM with 150mm lens. Diffusion created by a single layer of black nylon hose stretched over the lens. **APERTURE:** f/11. **SHUTTER SPEED:** 1/30 second. **FILM:** Kodak TMAX ISO 100.

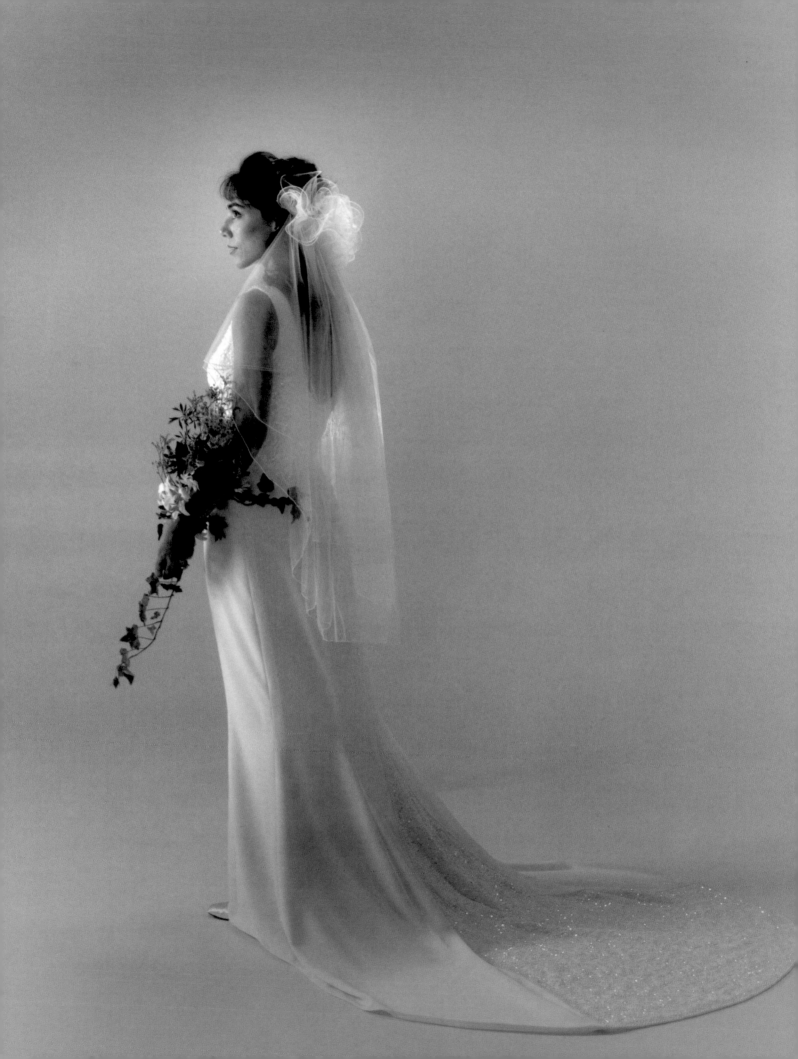

FULL-LENGTH POSING

This portrait is an example of full-length lighting and posing. To accomplish the pose, the bride stood with her weight on her front foot and with her back slightly arched. This created the soft and flattering S-curve that runs diagonally through the torso and ends with her train. You should also note that the lighting was used specifically to draw attention to her face and hair. As you can see, the placement of the main and kicker lights make this stand out as the area of greatest contrast.

### LIGHTING RELATIONSHIPS

f/5.6— separation light (-2 stops)

f/8.0— kicker light (-1 stop)

f/8.0— hair light (-1 stop)

f/11.0— **main light**

**WHITE BACKGROUND WITH NO LIGHT ON IT**

**SEPARATION LIGHT:** Lumedyne with silver reflector aimed at shoulder height. Incident reading: f/5.6.

**HAIR LIGHT:** White Lightning 1200 in self-made 6" x 18" foamcore soft box. Incident reading: f/8.

**KICKER LIGHT:** White Lightning 1200 with 20° grid spot aimed at face. Incident reading: f/8.

**REFLECTOR:** Photogenic super silver.

**SUBJECT**

**MAIN LIGHT:** Larson 24" x 24" soft box with Photogenic Portamaster. Incident reading: f/11.

**CAMERA:** Mamiya RZ67 with 90mm lens. **APERTURE:** f/11.5. **SHUTTER SPEED:** 1/30 second. **FILM:** Kodak TMAX ISO 100.

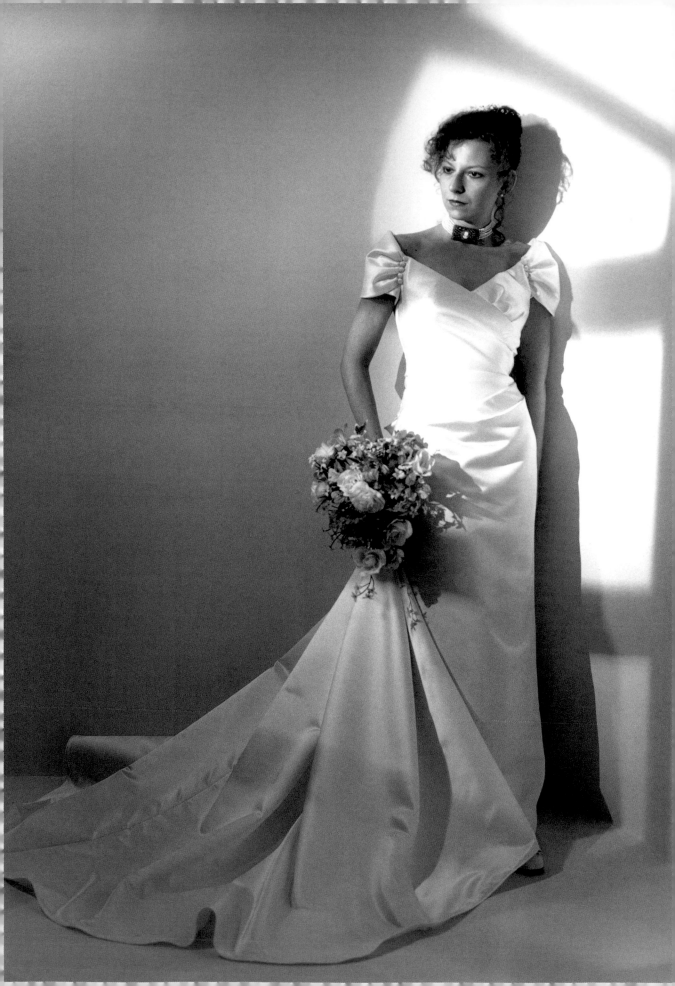

BARE BULB LIGHTING

Bare bulb lighting was used in this portrait to create the hard, well defined shadows that make it such a graphic image. A soft box was also used to provide a small amount of fill light. This opened up the shadows by one stop and kept them from going black and being too harsh.

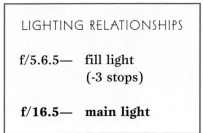

LIGHTING RELATIONSHIPS

f/5.6.5— fill light
(-3 stops)

f/16.5— main light

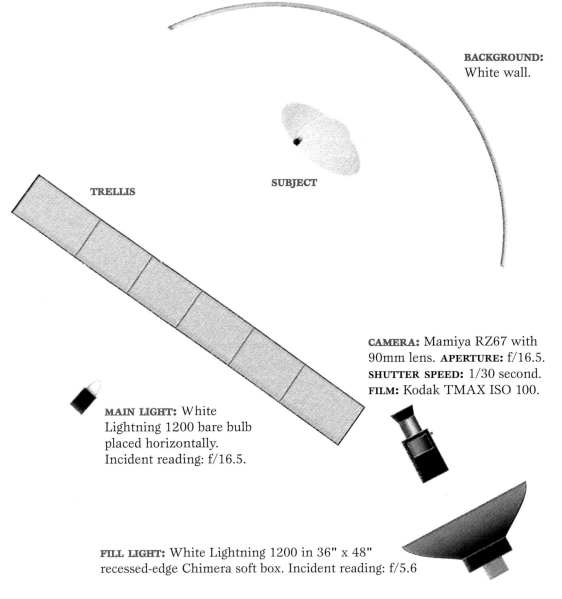

**BACKGROUND:** White wall.

**TRELLIS**

**SUBJECT**

**MAIN LIGHT:** White Lightning 1200 bare bulb placed horizontally. Incident reading: f/16.5.

**CAMERA:** Mamiya RZ67 with 90mm lens. **APERTURE:** f/16.5. **SHUTTER SPEED:** 1/30 second. **FILM:** Kodak TMAX ISO 100.

**FILL LIGHT:** White Lightning 1200 in 36" x 48" recessed-edge Chimera soft box. Incident reading: f/5.6

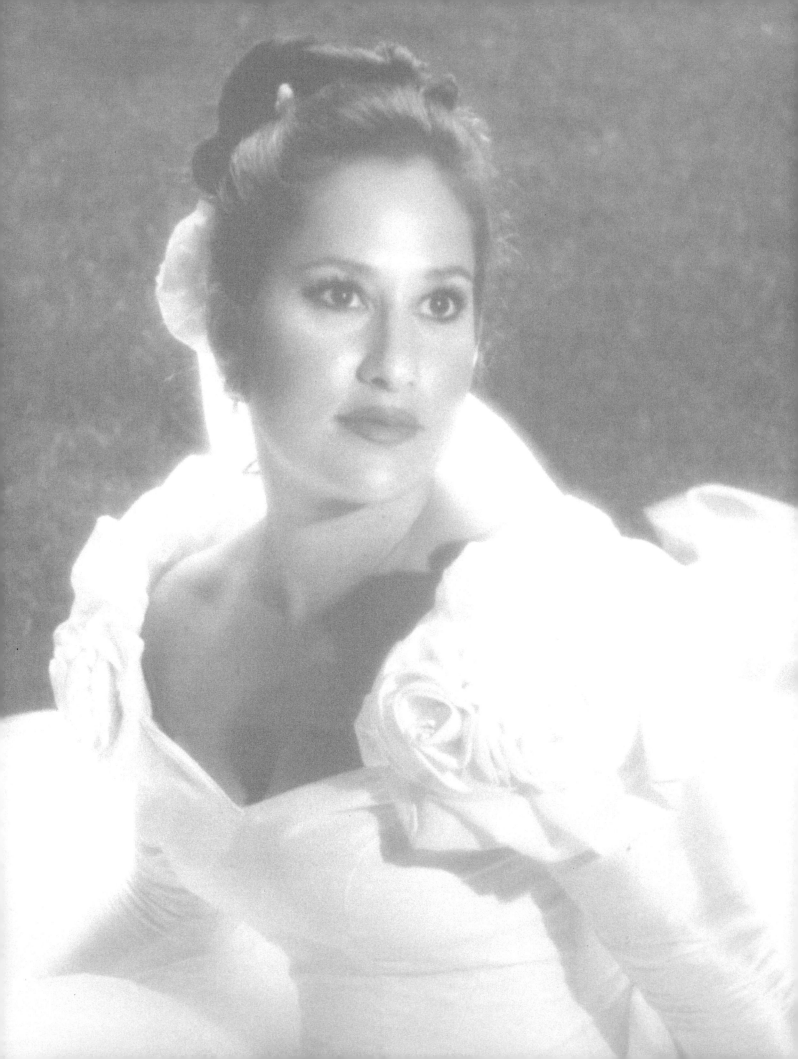

# 6

# LOCATION
# SESSIONS:

## TECHNIQUES
## AND IMAGES

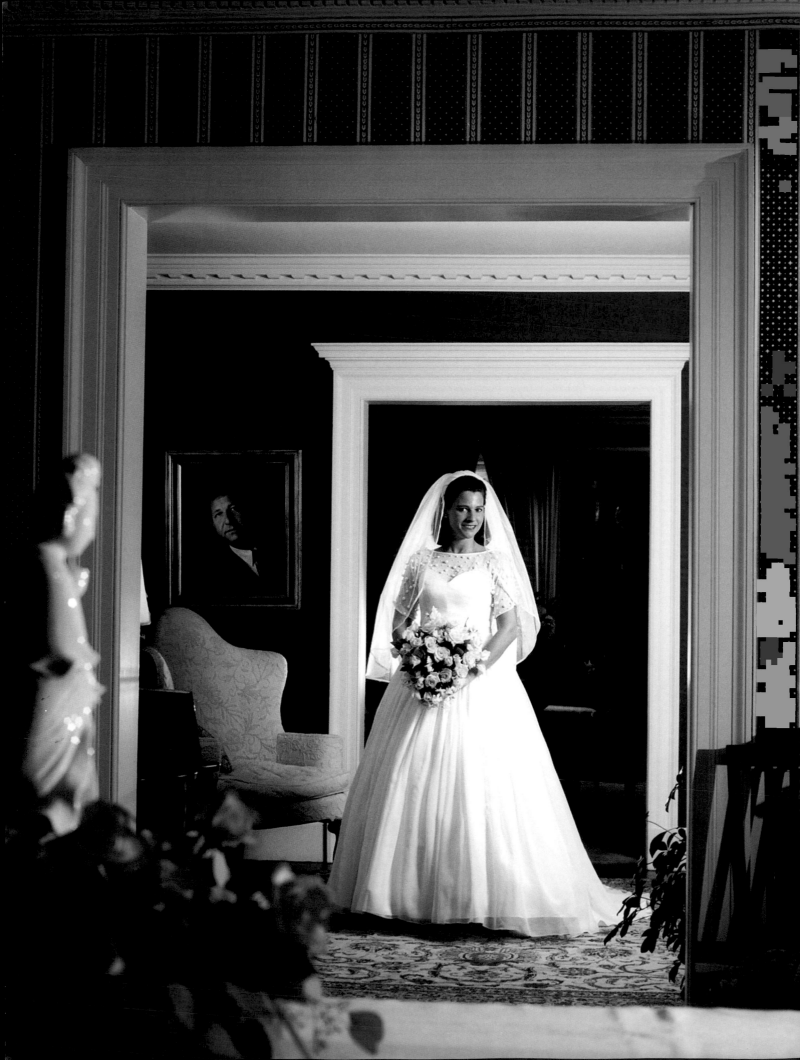

EXPOSURE DECISIONS

This image is a useful example for exploring the decisions made when determining the correct exposure for a portrait. As you can see, five image planes were involved: the figurine, the first archway, the subject, the second archway and the background wall.

Step one was to determine the shutter speed. To do this, I needed to determine the existing light levels on the various planes. It was important that their exposure range did not exceed two stops over or under the main light exposure on the subject. I usually choose a setting between f/8 and f/11. Based on this, I proceeded to meter the other elements in the room. The incident reading for the window light was f/5.6 at 1/2 second. The incandescent light illuminating the first archway read f/5.6.5 at 1/2 second. Thus 1/2 second was set as the shutter speed. Both readings would yield exposures 1.5–2 stops under the main light. Once your shutter speed is determined, subsequent readings should be made with modeling lights off and the meter set to 1/2 second.

Step two was to determine the subject exposure. Based on the calculated shutter speed (from step one), I selected f/11, based on the incident reading of the main light.

Step three was to get the correct exposure on the foreground figurine. I wanted it to be visible but not to create overpowering specular highlights. Therefore, I set the accent light on the figurine at f/8, one stop lower than the main light. Using a Polaroid can be very helpful for evaluating this type of situation.

Step four was to set the separation light that illuminated the bride from the back. This was needed to

| LIGHTING RELATIONSHIPS | |
| --- | --- |
| f/5.6— | window light, background (-2 stops) |
| f/5.6.5— | candelabra (-1.5 stop) |
| f/8— | figure (-1 stop) |
| f/8.5— | separation light (-.5 stop) |
| **f/11.0—** | **main light** |

highlight the veil, but should not be too bright—otherwise it could overwhelm the bride and make the background look darker than it was. Setting this carefully was especially important because light coming toward the camera tends to accelerate and appear brighter. Using a reflected reading of the light through the veil, I determined the best setting to be f/8.5 at 1/2 second.

For a diagram of this setup, please refer to page 22.

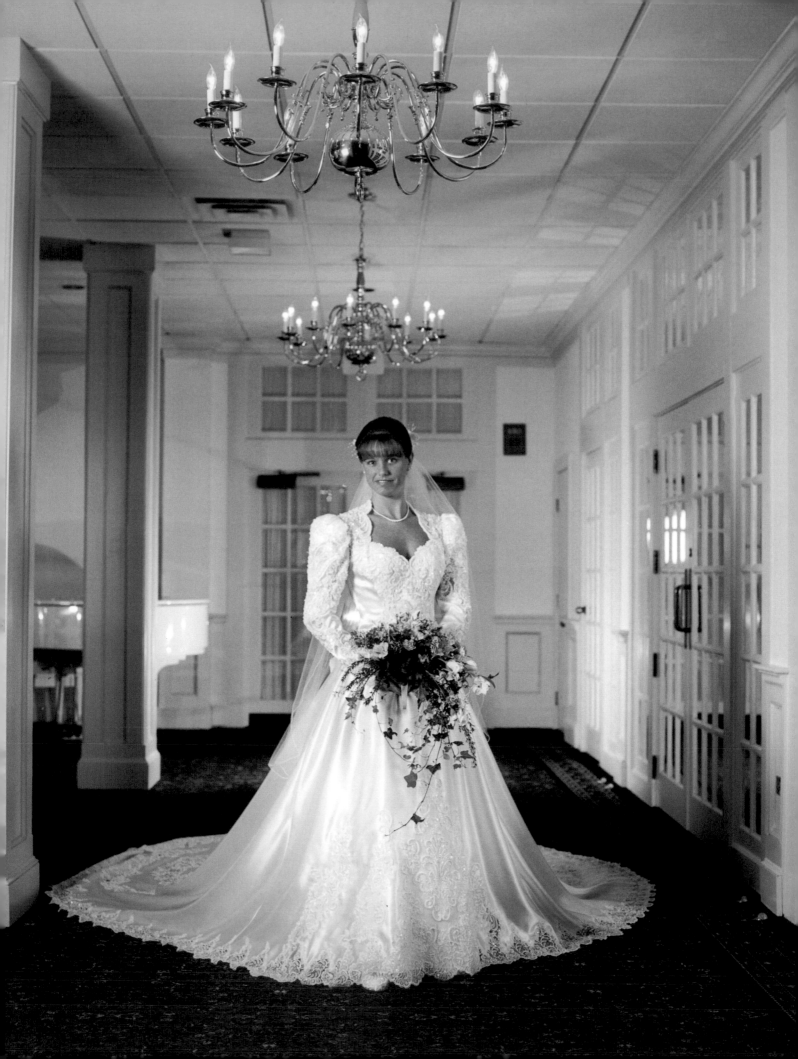

BLENDED LIGHTING CONDITIONS

This image illustrates the use of combined light sources, in this case ambient light with strobe light. The reading of the ambient light was f/5.6.5 at 1/4 second, and this reading was used for the shutter speed, ensuring the exposure on the room would be 1.5 stops less than on the subject. The background light was set to f/8, which created bright highlights on the walls, since the glossy paint was not taken into consideration. A better setting for this light would have been f/5.6.5.

| LIGHTING RELATIONSHIPS | |
| --- | --- |
| f/5.6.5— | ambient light (-1.5 stop) |
| f/8.0— | background light (-1 stop) |
| f/11.0— | main light |

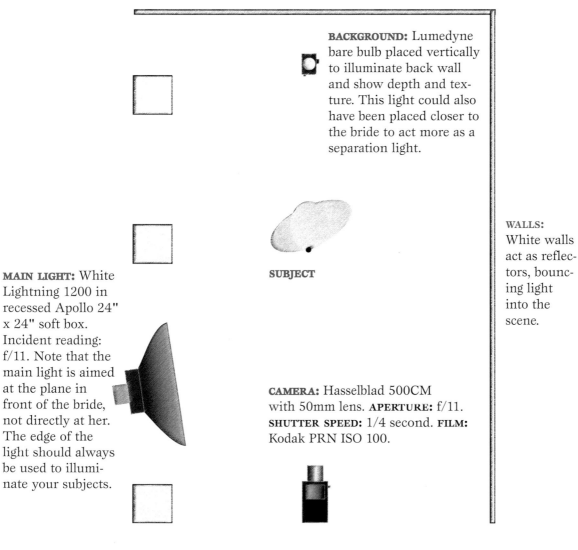

**BACKGROUND:** Lumedyne bare bulb placed vertically to illuminate back wall and show depth and texture. This light could also have been placed closer to the bride to act more as a separation light.

**WALLS:** White walls act as reflectors, bouncing light into the scene.

**SUBJECT**

**MAIN LIGHT:** White Lightning 1200 in recessed Apollo 24" x 24" soft box. Incident reading: f/11. Note that the main light is aimed at the plane in front of the bride, not directly at her. The edge of the light should always be used to illuminate your subjects.

**CAMERA:** Hasselblad 500CM with 50mm lens. **APERTURE:** f/11. **SHUTTER SPEED:** 1/4 second. **FILM:** Kodak PRN ISO 100.

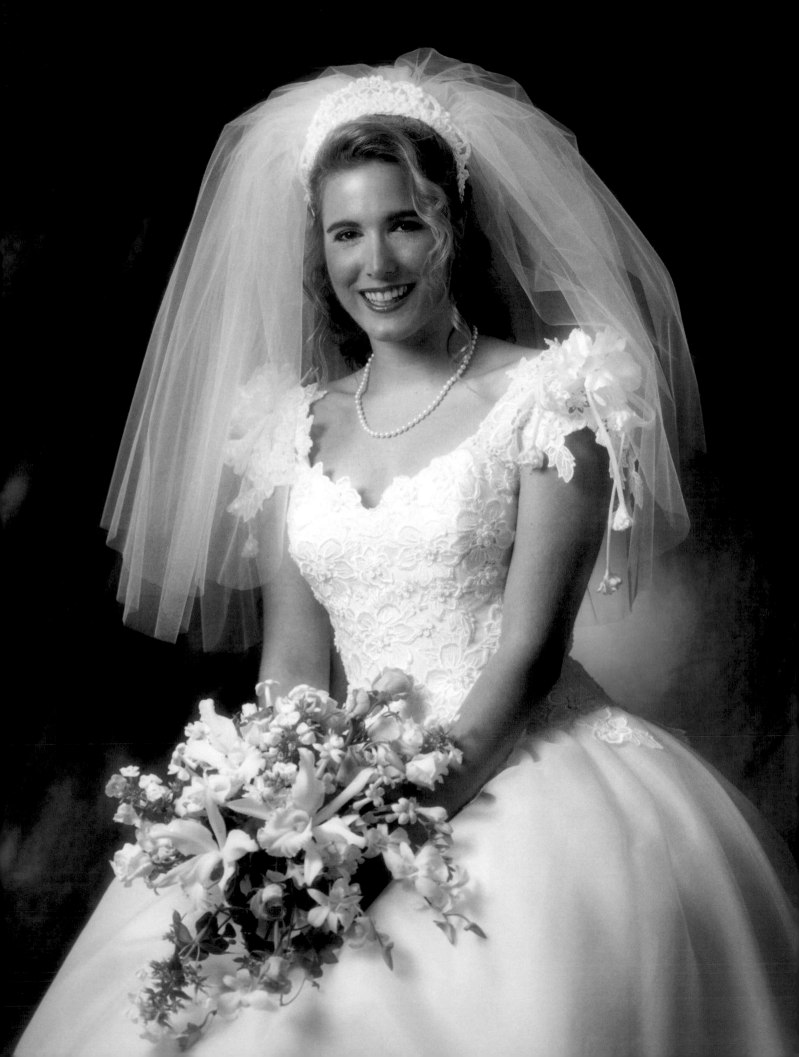

DIMINISHED SUNLIGHT

By selecting a high shutter speed (1/250 second), the effect of the bright sunlight from the window behind the subject was diminished. Note, however, that flash-synch shutter speeds this high are available only on cameras equipped with leaf shutters.

MAIN LIGHT CRITIQUE

The use of the background light could have been improved by more accurately centering its illumination behind the subject.

**WINDOW WITH DIRECT SUNLIGHT**

**DRAPED MUSLIN BACKGROUND**

Reflected reading of backlight sun on muslin: f/11 at 1/125 second.

**BACKGROUND LIGHT:** Lumedyne with silver parabolic reflector with blue gel. Reflected reading: f/8.

**SUBJECT**

**MAIN LIGHT:** White Lightning 1200 in recessed Apollo 30" x 30" soft box. Incident reading: f/11.

**REFLECTOR:** Larson 24" x 24" super silver.

**CAMERA:** Hasselblad 500CM with 150mm lens. **APERTURE:** f/11. **SHUTTER SPEED:** 1/250 second. **FILM:** Kodak PRN ISO 100.

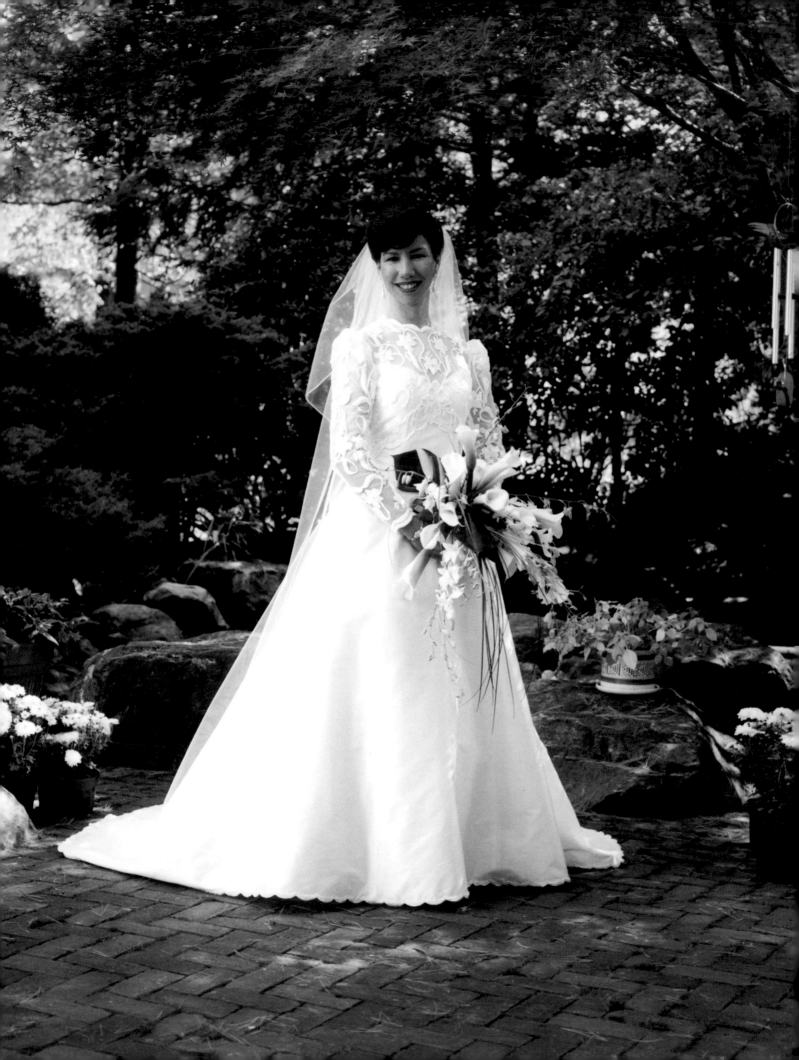

BALANCING SUNLIGHT

With direct sunlight hitting the subject from the left, the shadow area on the right side of the subject was too dark (the light ratio was too high). Soft fill flash was therefore added to balance the overall lighting situation. This on-camera light consisted of a Lumedyne flash with a self-made modifier to diffuse the light. It was set to f/8, ensuring that it *did not* brighten the diffused highlights on the left side of the subject, but *did* work to lighten the shadow area on the right side.

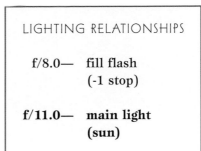

LIGHTING RELATIONSHIPS

f/8.0— fill flash (-1 stop)

f/11.0— main light (sun)

**FOLIAGE**

**FOLIAGE**

**FOLIAGE**

**SUBJECT**

**SUNLIGHT:** Metered at f/11 at 1/125 second.

**FILL LIGHT:** On-camera flash. Lumedyne in self-made foamcore scrim covered with draftman's vellum. Fill flash exposure: f/8.

**CAMERA:** Hasselblad 500CM on tripod with 80mm lens. **APERTURE:** f/11. **SHUTTER SPEED:** 1/125 second. **FILM:** Kodak VPS rated at ISO 80.

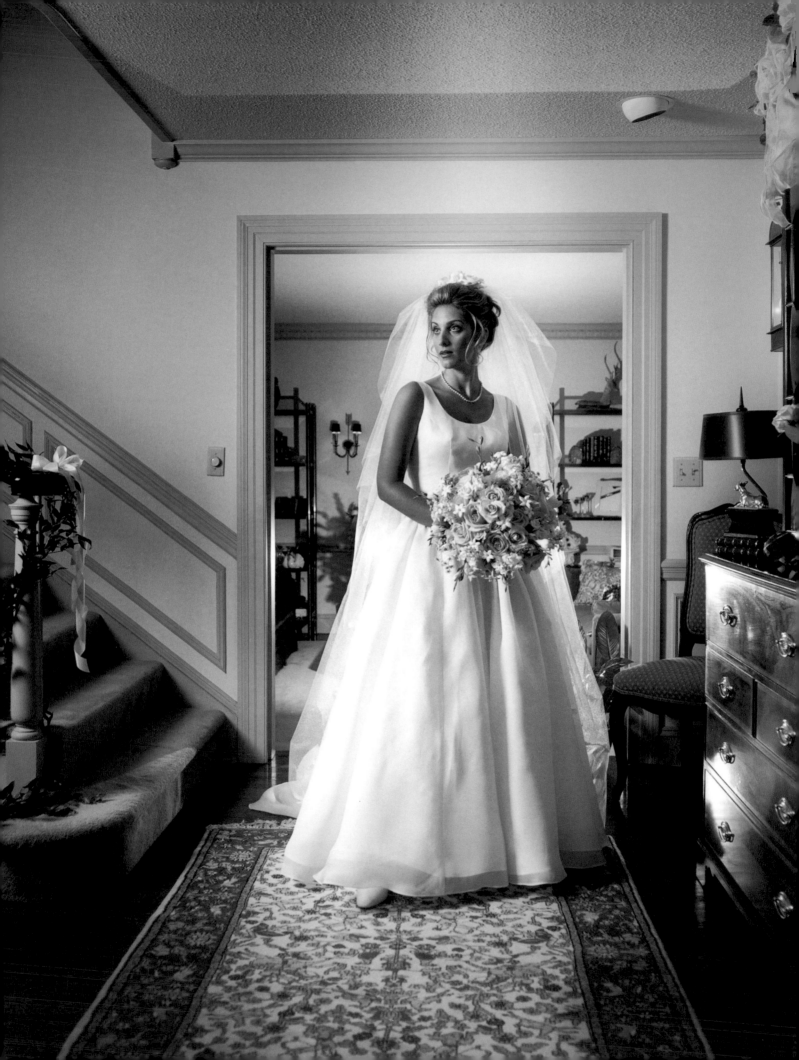

COMPOSITION

When creating a bridal portrait in an architectural setting, such as a church or home, you must pay attention to the lines of the architecture in the composition of the image. These strong lines can be very distracting, particularly if they intersect the body at the waist, neck or eyes. In this case, however, converging architectural lines serve as a wonderful tool for drawing the viewer's eyes toward the bride.

LIGHTING RELATIONSHIPS

f/8.5— background
light (-.5 stop)

f/11.0— main light

f/11.0— separation light

WALL

**BACKGROUND LIGHT/SEPARATION LIGHT:** Vertical Lumedyne bare bulb placed equidistant between subject and back wall of living room. Reflected reading on background: f/8. 5, reflected reading through veil: f/11.

WALL

WALL

STAIRCASE

CHEST OF DRAWERS

SUBJECT

**MAIN LIGHT:** 24" x 24" White Lightning 1200 in recessed Apollo soft box. Incident reading: f/11.

**CAMERA:** Hasselblad 500CM on tripod with 50mm lens. **APERTURE:** f/11. **SHUTTER SPEED:** 1/30 second. **FILM:** Kodak PRN ISO 100.

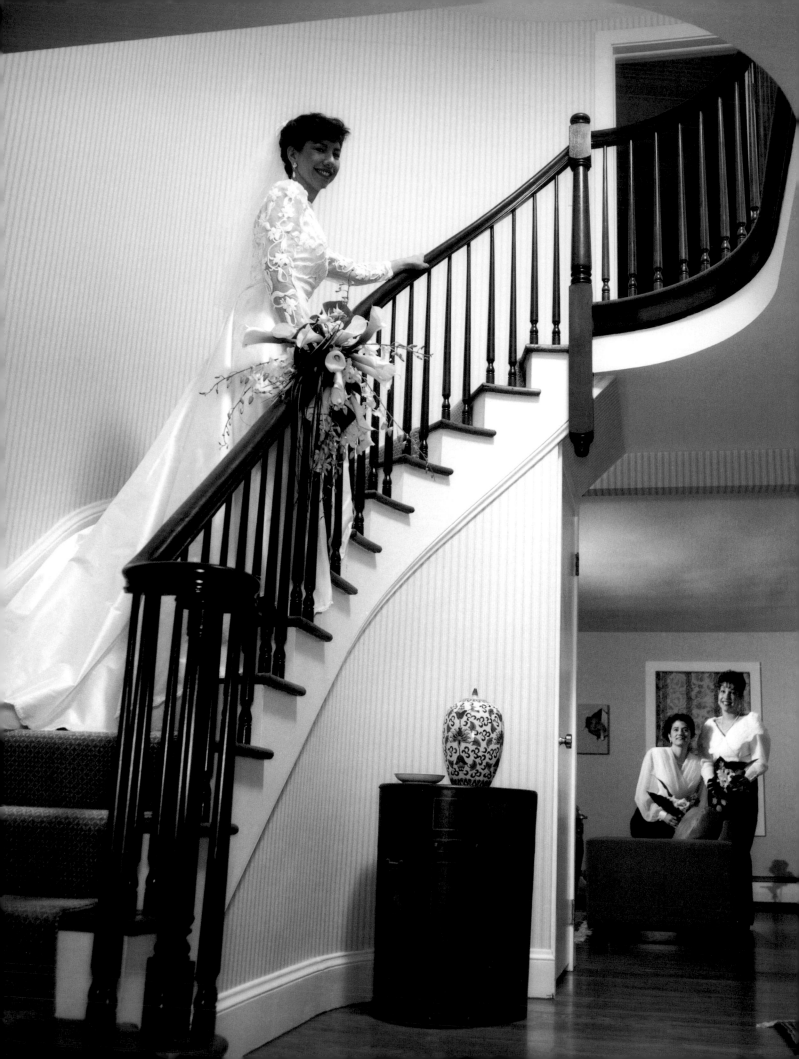

COMBINED FLASH TECHNIQUES

In this image, three types of flash lighting were used to illuminate the subjects. On the stairs, the bride is illuminated by indirect diffused light (light from the main light bounced onto her by the walls) and direct diffused light (the soft light directly from the on-camera fill flash). The two subjects in the background are lit by a third type of flash— bare bulb direct.

### LIGHTING RELATIONSHIPS

f/5.6.5—   fill light (-1 stop)

f/8.5—   primary main light

f/8.5—   secondary main light

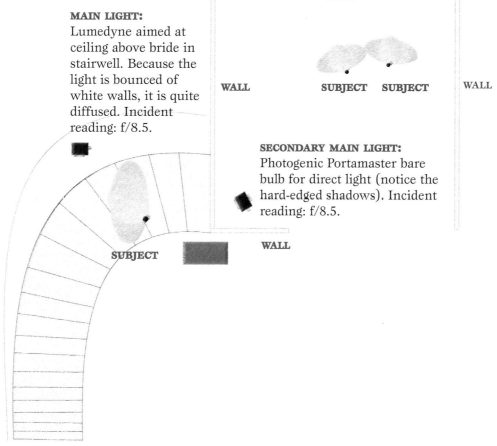

**MAIN LIGHT:** Lumedyne aimed at ceiling above bride in stairwell. Because the light is bounced of white walls, it is quite diffused. Incident reading: f/8.5.

**SECONDARY MAIN LIGHT:** Photogenic Portamaster bare bulb for direct light (notice the hard-edged shadows). Incident reading: f/8.5.

WALL
WALL
WALL
WALL
SUBJECT
SUBJECT
SUBJECT

**FILL LIGHT:** On-camera flash. Lumedyne in self-made 18" x 18" soft box covered with draftman's vellum. Used as fill light, set one stop below main light. Fill flash exposure: f/5.6.5 at 1/30 second.

**CAMERA:** Hasselblad 500CM on tripod with 40mm lens. **APERTURE:** f/8.5. **SHUTTER SPEED:** 1/30 second. **FILM:** Kodak VPS rated at ISO 80.

LATE DAY SUNLIGHT

Just before sunset, the light from the sky is soft and diffused—perfect for flattering portraits. Because the light of the sun comes from a very low angle at this time, it also provides excellent directional illumination. This helps to depict the shapes and textures of the subjects, their clothes and the setting. The result is a soft, painterly effect.

<div style="border:1px solid;">

LIGHTING RELATIONSHIPS

**f/8.0—** **main light (sun)**

</div>

**SUBJECTS**

**SUNLIGHT:** Just before sunset. Incident reading: f/8 at 1/30 second.

**CAMERA:** Hasselblad 500CM on tripod with 80mm lens. **APERTURE:** f/8. **SHUTTER SPEED:** 1/30 second. **FILM:** Fuji NGH II ISO 800.

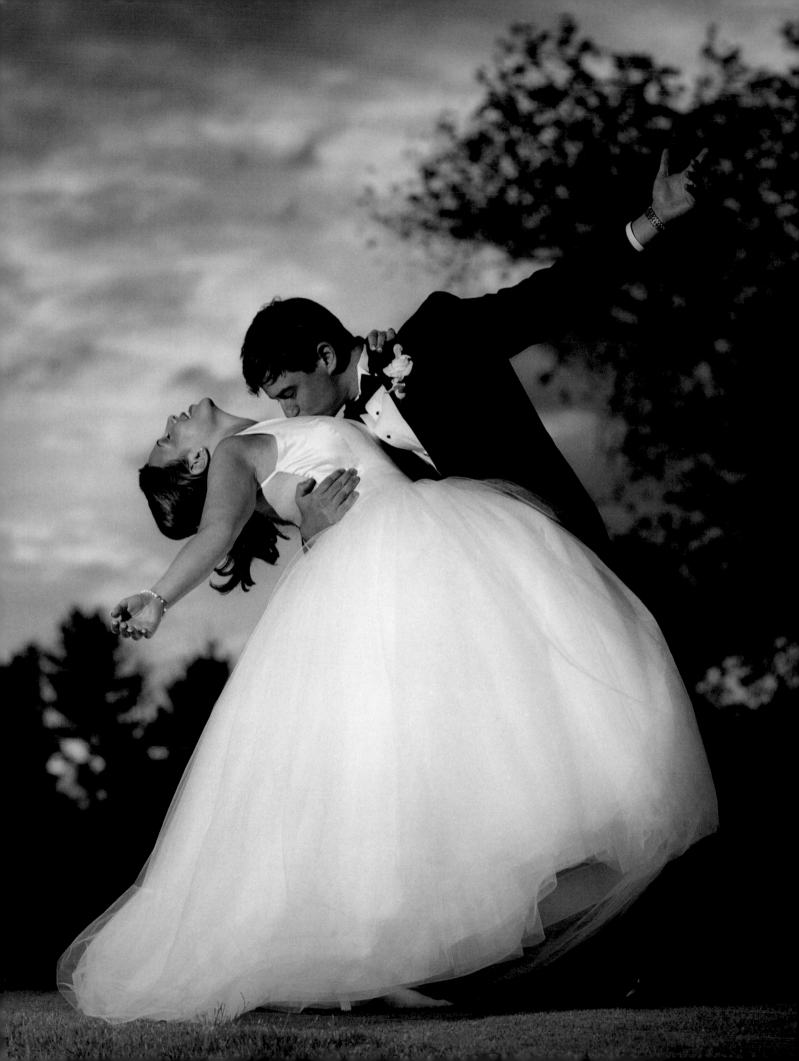

BACKGROUND

In this portrait of a bride and groom, the open sky in the background was quite bright and needed to be controlled. To accomplish this, a main and fill light were placed to illuminate the front of the couple.

These lights were set so that the couple would receive enough light to expose them correctly. The background would, however, be 1.5 stops underexposed (darkened) because of the faster shutter speed of $^1/_{250}$ second.

LIGHTING RELATIONSHIPS

f/8.0—   fill light
        (-1 stop)

f/11.0—   **main light**

**BACKGROUND:** Sky metered with reflective meter at f/5.6.5 at 1/250 second.

**TREELINE**

**TREELINE**

**SUBJECT**

**MAIN LIGHT:** Lumedyne with silver reflector, placed about fifteen feet from subjects. Incident reading: f/11.

**FILL LIGHT:** On-camera Lumedyne flash in self-made 18" x 18" soft box covered with draftman's vellum for diffusion. Placed about fifteen feet from subjects. Incident reading: f/8.

**CAMERA:** Hasselblad 500CM with 80mm lens. **APERTURE:** f/11. **SHUTTER SPEED:** 1/250 second. **FILM:** Kodak PRN ISO 100.

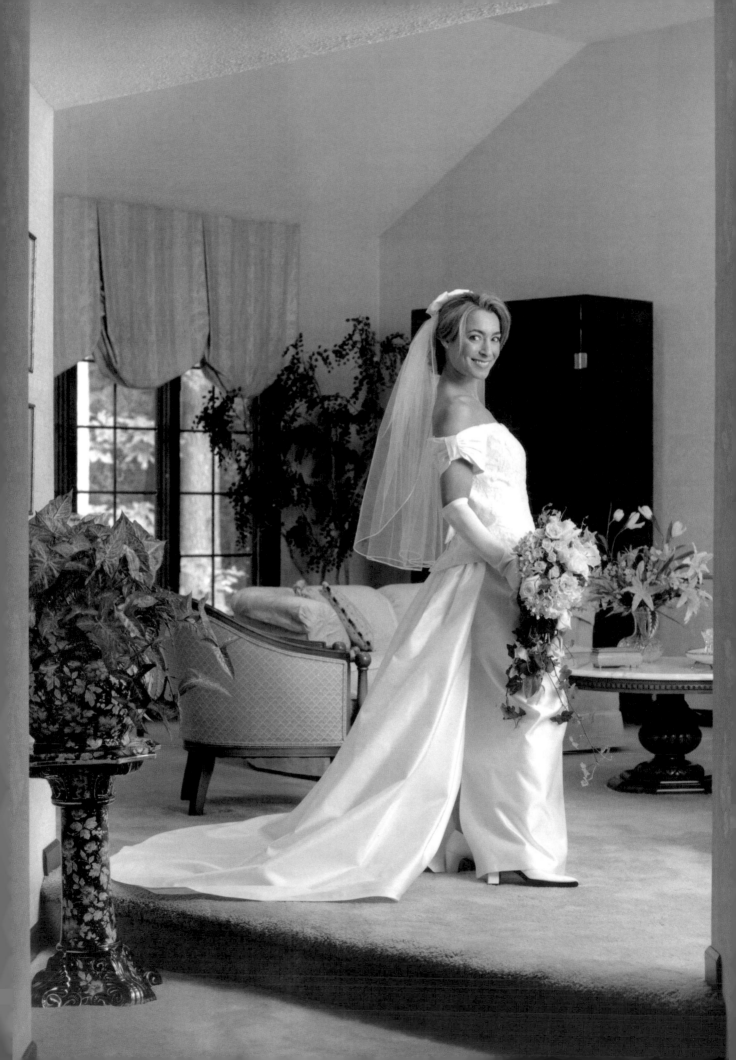

MIXED LIGHTING

Here, direct sunlight, indoor ambient light and bounced flash are combined for a very natural effect. The main light was obscured from the camera by placing it just inside the doorway. It was then directed toward the sheer white curtains on the window. This bounced soft, supplementary light onto the bride.

---

**LIGHTING RELATIONSHIPS**

**f/8.5—**  **main light**

**f/8.0—**  **background light (-.5 stop)**

---

**REAR WALL**

**SUNLIGHT:** Direct light through windows. The reflected reading on this window was f/16 at 1/30 second—a stop and a half greater than my main light was able to produce even at full power. Changing the shutter speed to 1/125 darkened the background to f/8. Incident reading: f/8 at 1/125 second. (See Main Light for the consequence of this.)

**MAIN LIGHT:** Switching to a shutter speed of 1/125 (see Sunlight) meant I lost the appearance of the ambient light from this window. Therefore, I added a White Lightning 1200 with silver parabolic reflector. Aimed into sheer white curtain, this supplemented the diffused light without changing its quality. This was set 1/2 stop brighter than the background light to ensure that the bride would stand out. Incident reading: f/8.5.

**SUBJECT**

**CAMERA:** Hasselblad 500CM with 50mm lens. **APERTURE:** f/8.5. **SHUTTER SPEED:** 1/125 second. **FILM:** Kodak TMAX ISO 100.

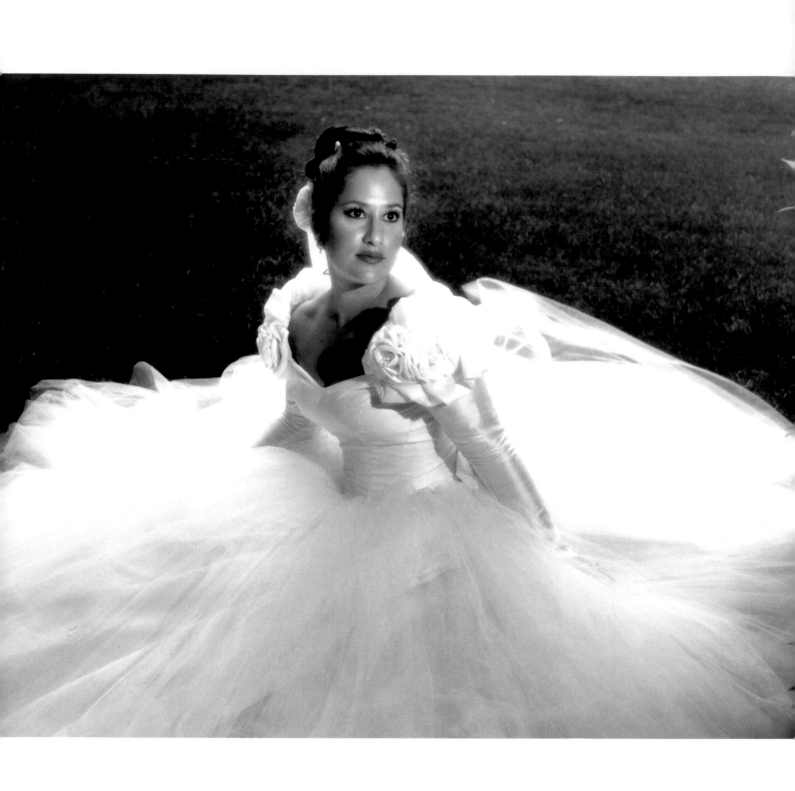

SUNLIGHT AND STROBE LIGHT

This image illustrates the blending of direct sunlight and off-camera strobe. Here, the sun in the background was very bright. Using a Lumedyne flash and silver reflector to illuminate the bride helped to balance the light on the scene, but not enough. Therefore, I needed to choose whether to lose texture on the grass or on the gown. I chose to sacrifice the gown's highlights to maintain the desired exposure on the bride's face.

| LIGHTING RELATIONSHIPS | |
|---|---|
| f/32— | separation light light (+2 stops) |
| f/22— | main light |

**SEPARATION LIGHT:** The sun acted as the separation light. Incident reading: f/32 at 1/250 second.

**MAIN LIGHT:** Lumedyne flash at full power with silver parabolic reflector. Incident reading: f/22.

**SUBJECT**

**FILL LIGHT:** Larson 24" x 24" super silver, placed just close enough to be out of camera range.

**GOBO:** The limbs of a bush between the light and the subject act as a gobo, preventing lens flare.

**CAMERA:** Hasselblad 500CM with 150mm lens. A higher camera angle was used to avoid lens flare. **APERTURE:** f/22. **SHUTTER SPEED:** 1/250 second. **FILM:** Kodak TMAX ISO 100.

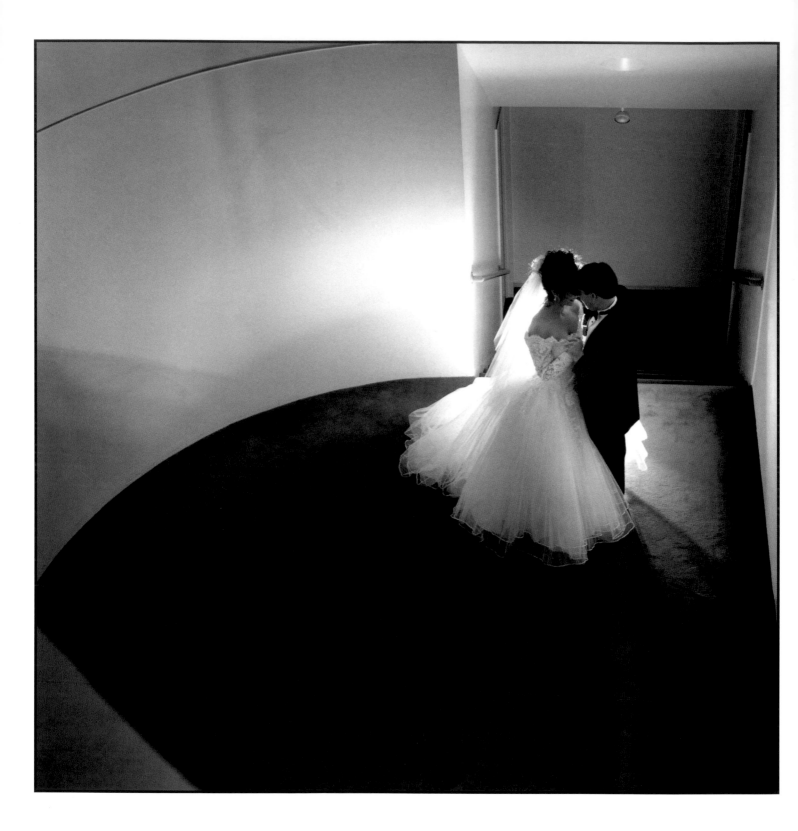

EXPOSURE

In this portrait, exposure was used as a creative technique to darken the foreground and create a partial silhouette on the couple. To accomplish this, the background light was set to f/11. The camera was set to expose correctly the background area illuminated by this light. Since the ambient light and fill light were two stops lower (both at f/5.6), the areas illuminated exclusively by these were underexposed for a very dramatic look.

---

**LIGHTING RELATIONSHIPS**

f/5.6—   fill light

f/5.6—   ambient light

f/11.0—   separation/ background light

---

**SEPARATION/BACKGROUND LIGHT:** Lumedyne bare bulb flash placed vertically. Reflected reading: f/11.

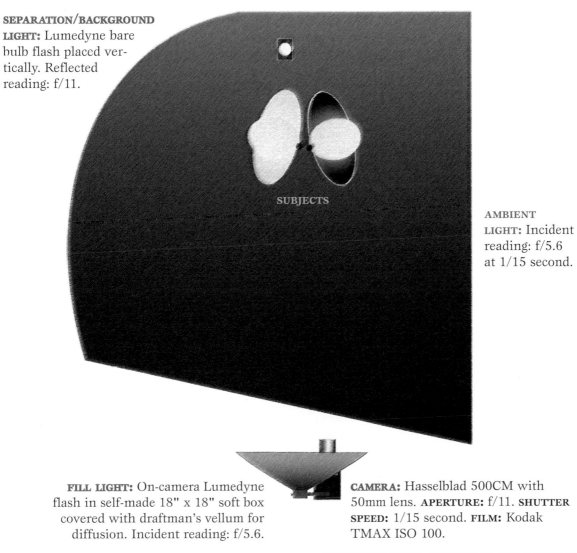

SUBJECTS

**AMBIENT LIGHT:** Incident reading: f/5.6 at 1/15 second.

**FILL LIGHT:** On-camera Lumedyne flash in self-made 18" x 18" soft box covered with draftman's vellum for diffusion. Incident reading: f/5.6.

**CAMERA:** Hasselblad 500CM with 50mm lens. **APERTURE:** f/11. **SHUTTER SPEED:** 1/15 second. **FILM:** Kodak TMAX ISO 100.

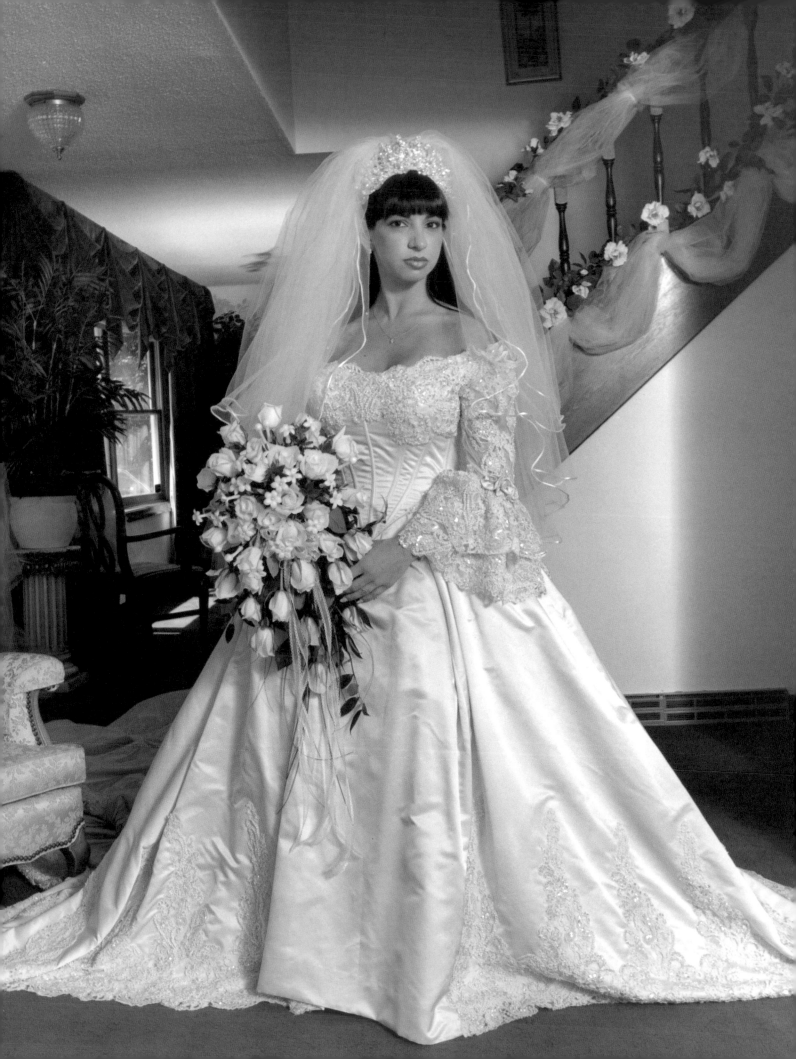

DIMINISHED SUNLIGHT

When setting up this shot, I needed to first consider the brightest element in the scene—the dining room window that had a reflective reading of f/16 ant 1/30 second. As noted earlier, my aperture of choice is f/8.5. If I had made the exposure at this setting, the window would have been a distracting hot spot. By making the exposure at f/8.5 with shutter speed of 1/125, I was able to underexpose the window, making it half a stop lower than the main light. Doing this, however, lowered the ambient light in the room. To compensate for this loss, a Lumedyne flash was added. This flash was aimed at the ceiling and added some depth.

> LIGHTING RELATIONSHIPS
>
> f/8—  background light (-.5 stop)
>
> f/8.5—  main light

**BACKGROUND LIGHT:** Window light metered at f/16 at 1/30 second. To compensate, the image was exposed at f/8.5 at 1/125 second, making this area .5 stop darker than the main light.

**BACKGROUND LIGHT:** To compensate for the reduced ambient light, a Lumdyne flash with silver reflector was added and aimed toward the ceiling. Reflected reading: f/8.

STAIRCASE

SUBJECT

CAMERA: Hasselblad 500CM with 80mm lens. APERTURE: f/8.5. SHUTTER SPEED: 1/125 second. FILM: Kodak CN ISO 400.

MAIN LIGHT: White Lightning 1200 in recessed Apollo 24" x 24" soft box. Incident reading f/8.5 at 1/125 second.

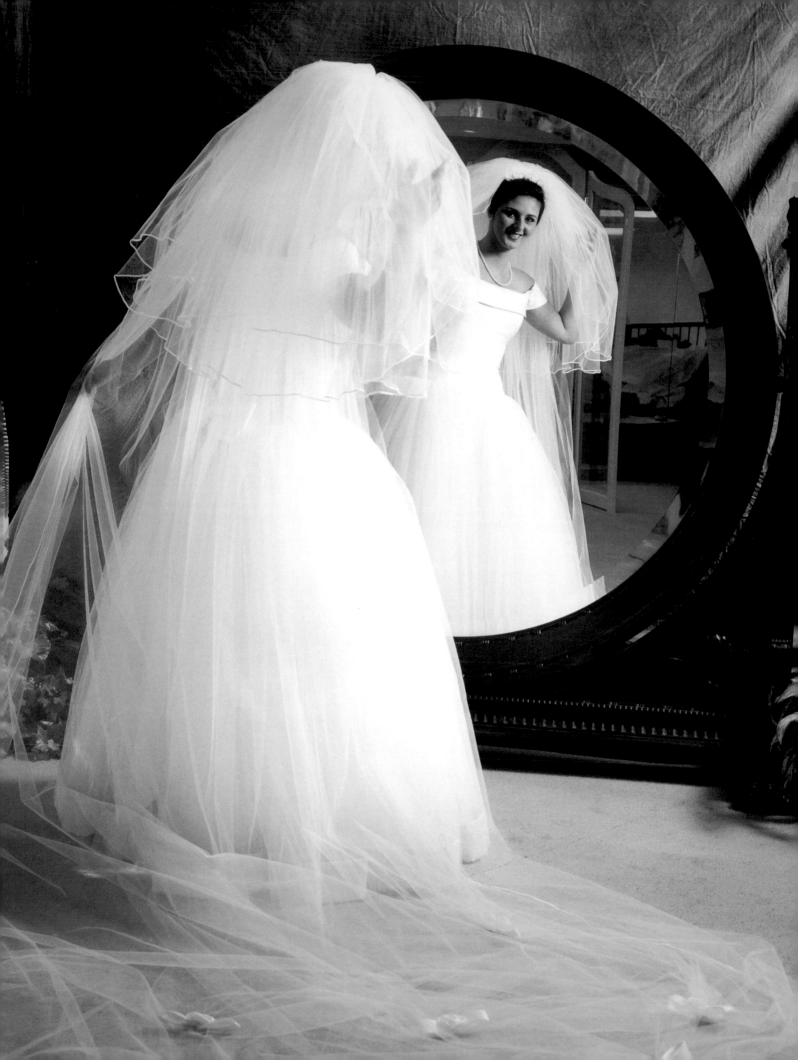

PROPS, SET AND LENS SELECTION

Believe it or not, this bride was photographed in a busy bridal salon—with many distractions and people in the background. Using a large mirror and the muslin in the background helped to create a composition where distrac-tions were reduced. Using a 50mm lens allowed me to get close enough to the bride that the gown could hide the camera from the mirror. It also provided the required depth of field to keep both the gown and the reflection in the mirror in focus.

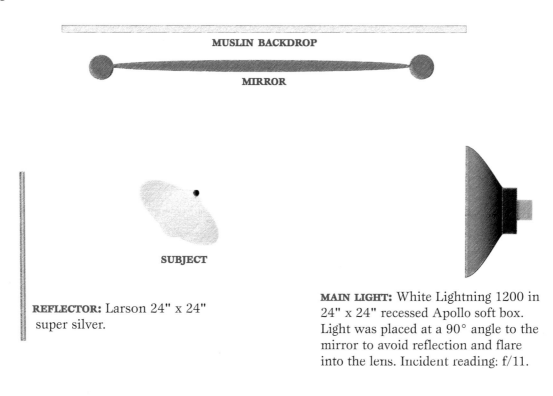

LIGHTING RELATIONSHIPS

f/11.0—   main light

**MUSLIN BACKDROP**

**MIRROR**

**SUBJECT**

**REFLECTOR:** Larson 24" x 24" super silver.

**MAIN LIGHT:** White Lightning 1200 in 24" x 24" recessed Apollo soft box. Light was placed at a 90° angle to the mirror to avoid reflection and flare into the lens. Incident reading: f/11.

**CAMERA:** Hasselblad 500CM with 50mm lens. Focus was on the bride's reflection in the mirror, not on the mirror's frame. **APERTURE:** f/11. **SHUTTER SPEED:** 1/30 second. **FILM:** Kodak PRN ISO 100.

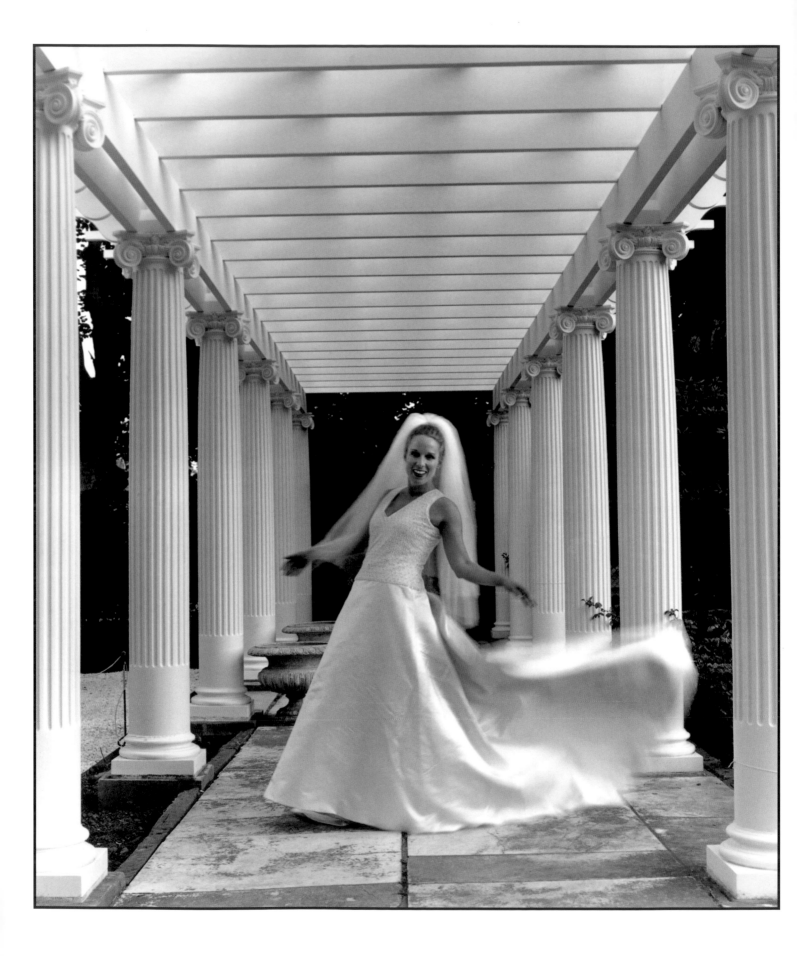

MOTION AND LOCATION

This location provided not only a beautiful backdrop, but also excellent lighting. Shooting late in the day, the light though the columns is directional enough to reveal shape and texture, but still very diffuse, with soft open shadows that are extremely flattering. The dark foliage behind the bride also provided nice separation. To capture the motion of the bride's arms, train and veil, I used a slow shutter speed—1/15 second. I used a tripod and cable release to ensure that camera motion would not be a problem.

| LIGHTING RELATIONSHIPS |
| --- |
| f/8.5— main light (sun) |

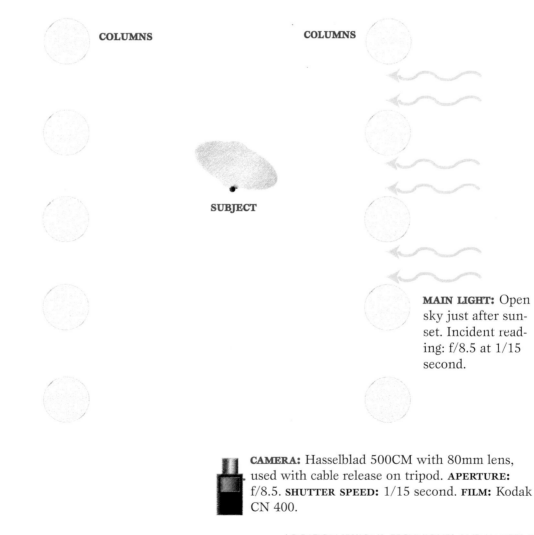

COLUMNS     COLUMNS

SUBJECT

**MAIN LIGHT:** Open sky just after sunset. Incident reading: f/8.5 at 1/15 second.

**CAMERA:** Hasselblad 500CM with 80mm lens, used with cable release on tripod. **APERTURE:** f/8.5. **SHUTTER SPEED:** 1/15 second. **FILM:** Kodak CN 400.

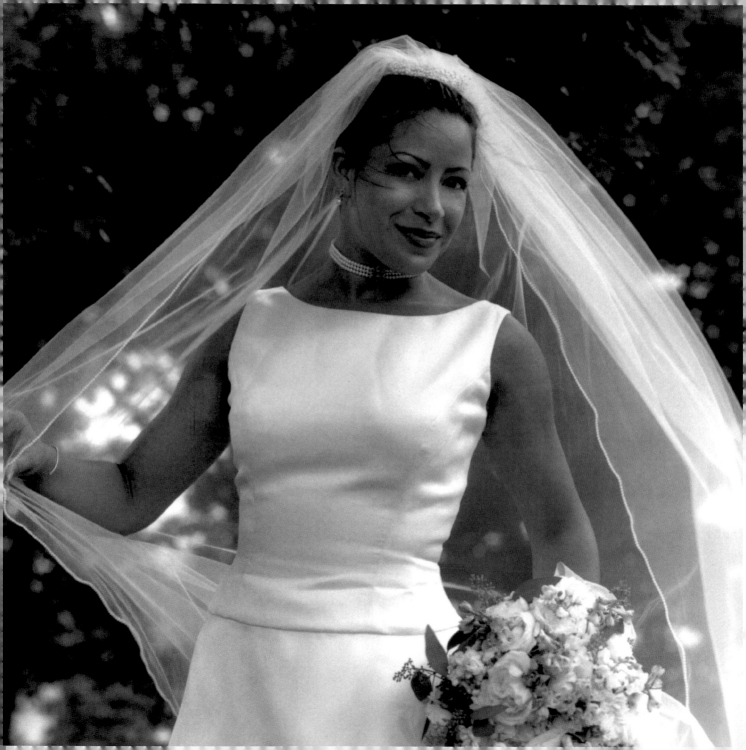

COMPOSITION

Diagonal lines generally create stronger compositions than vertical or horizontal ones. Here, the diagonals are used to create a triangle. Notice how these lines drawn by the veil and the bride's raised hand create a sense of motion. Good natural light works well for portraits like this, since the subject can move around more freely within the area, and without need for repositioning lights.

LIGHTING RELATIONSHIPS

**f/11.0—  main light
(open sky)**

**MAIN LIGHT:** Open sky. Incident reading: f/11 at 1/60 second.

**CAMERA:** Hasselblad 500CM with 150mm lens and lens shade. **APERTURE:** f/11. **SHUTTER SPEED:** 1/60 second. **FILM:** Kodak CN 400.

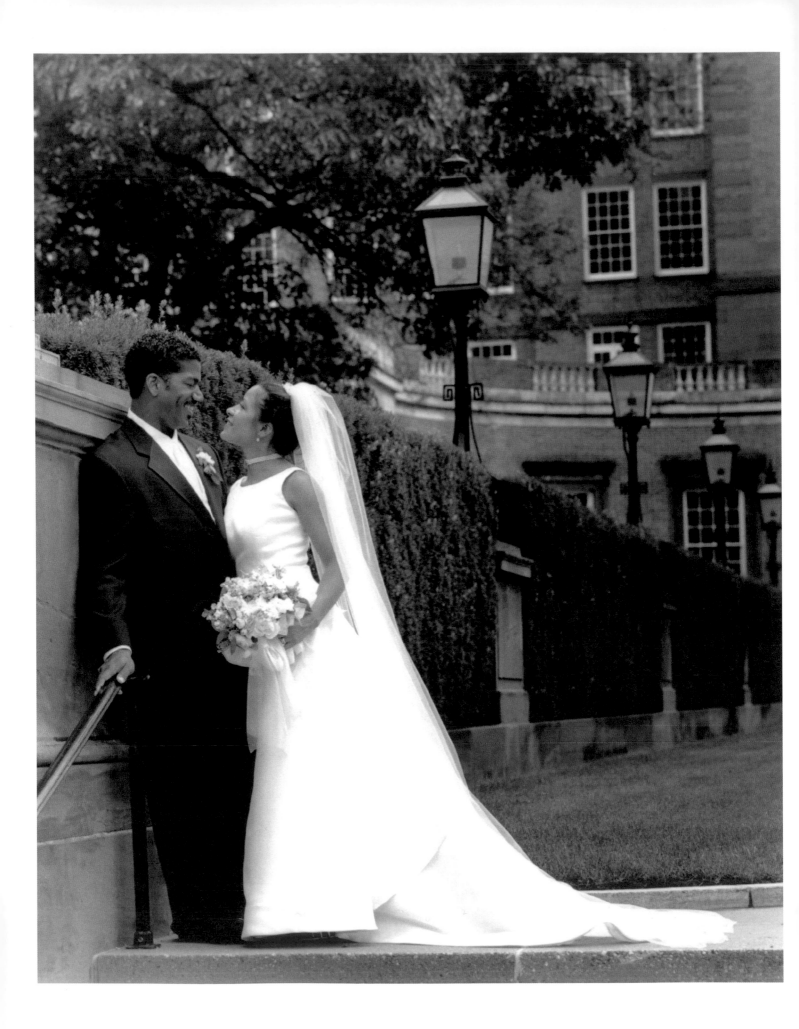

### COMPOSITION

In a portrait, lines used in the composition should always be carefully evaluated to ensure that they lead to the subject, not *through* the subject. As you can see in the diagram below, the portrait on the facing page demonstrates this concept. In it, diagonal lines (a particularly powerful compositional tool) lead from both edges of the frame in toward the subjects. Notice, however, that the one line that runs through the entire frame (the top of the hedge row) was placed just above the subject's heads and does not run through them.

### EXPOSURE

With incident metering and accurate film testing, you can be sure that black and white tones will render properly. Here, the couple's dark skin tones, the white gown and the black tuxedo all show detail, indicating that the negative was correctly exposed.

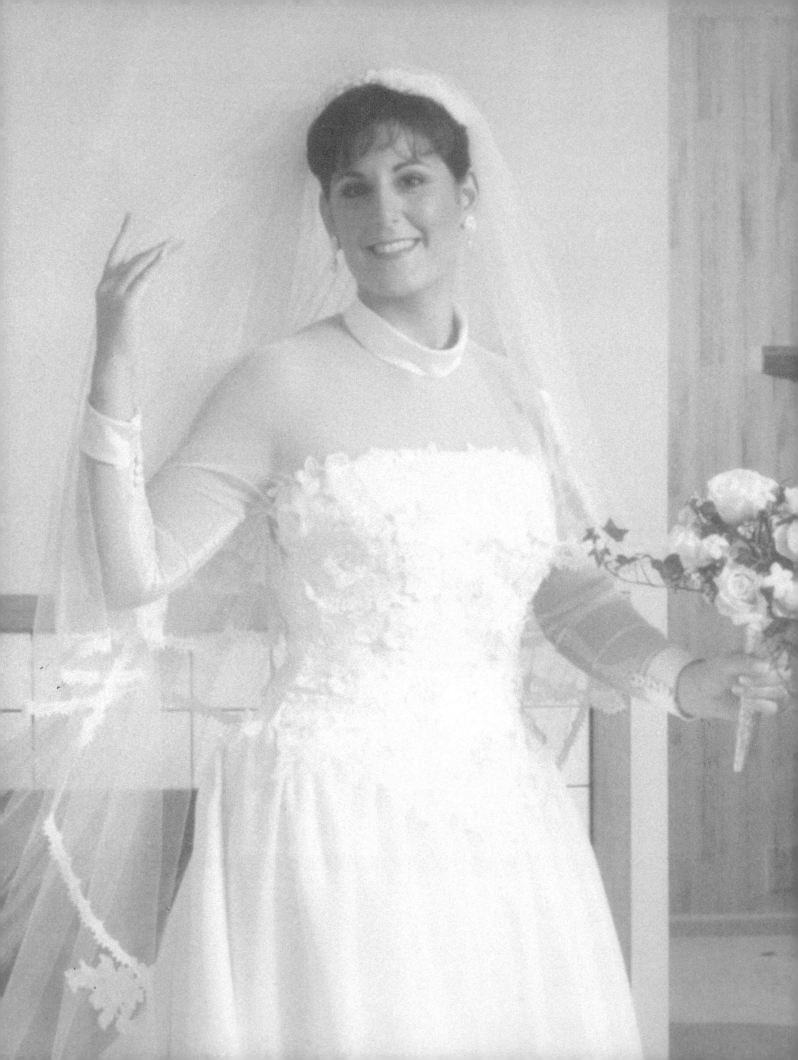

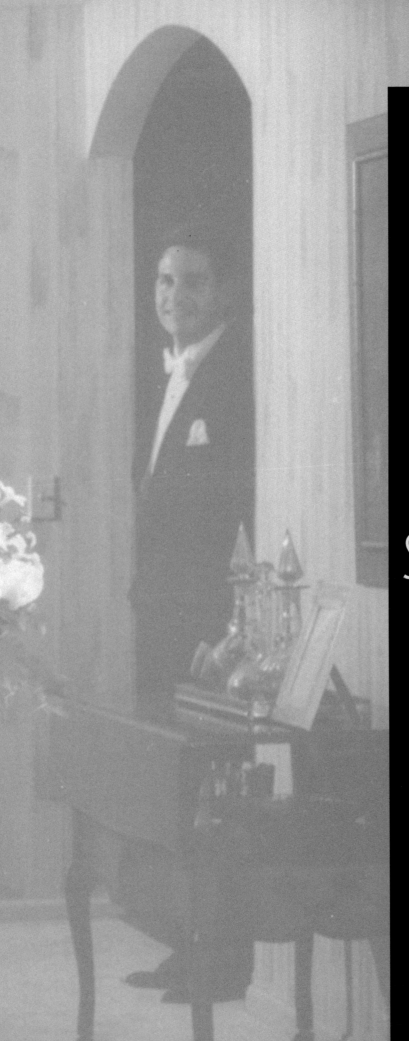

# 7

# SHOWING
# SUPPORT:

## TECHNIQUES
## AND IMAGES

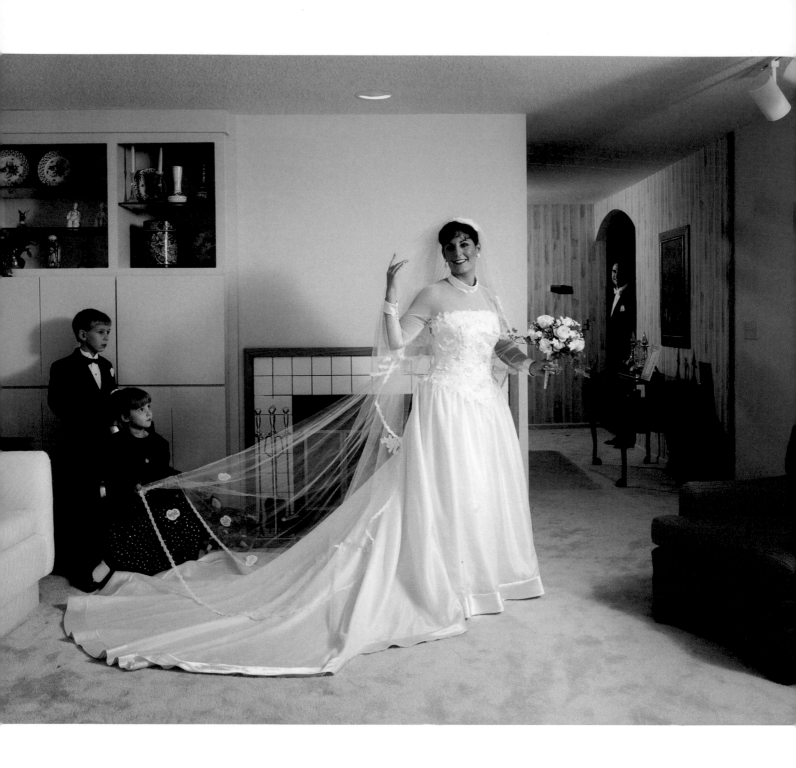

LIGHTING

Using two off-camera main lights allows additional dimension to be created in a portrait. Here, two planes of exposure were used, one for the bride and ring bear-ers and one for the groom. Dragging the shutter (using a 1/15 second expo-sure) unified the effect by allowing the ambient light to soften the shadows (see page 11).

<table>
<tr><td colspan="2">LIGHTING RELATIONSHIPS</td></tr>
<tr><td>f/11.0—</td><td>main light</td></tr>
<tr><td>f/11.0—</td><td>second main light</td></tr>
</table>

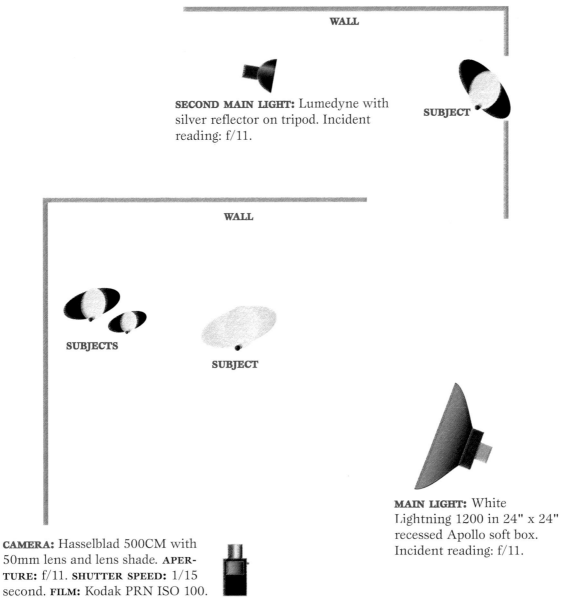

**WALL**

**SECOND MAIN LIGHT:** Lumedyne with silver reflector on tripod. Incident reading: f/11.

**SUBJECT**

**WALL**

**SUBJECTS**

**SUBJECT**

**MAIN LIGHT:** White Lightning 1200 in 24" x 24" recessed Apollo soft box. Incident reading: f/11.

**CAMERA:** Hasselblad 500CM with 50mm lens and lens shade. **APER-TURE:** f/11. **SHUTTER SPEED:** 1/15 second. **FILM:** Kodak PRN ISO 100.

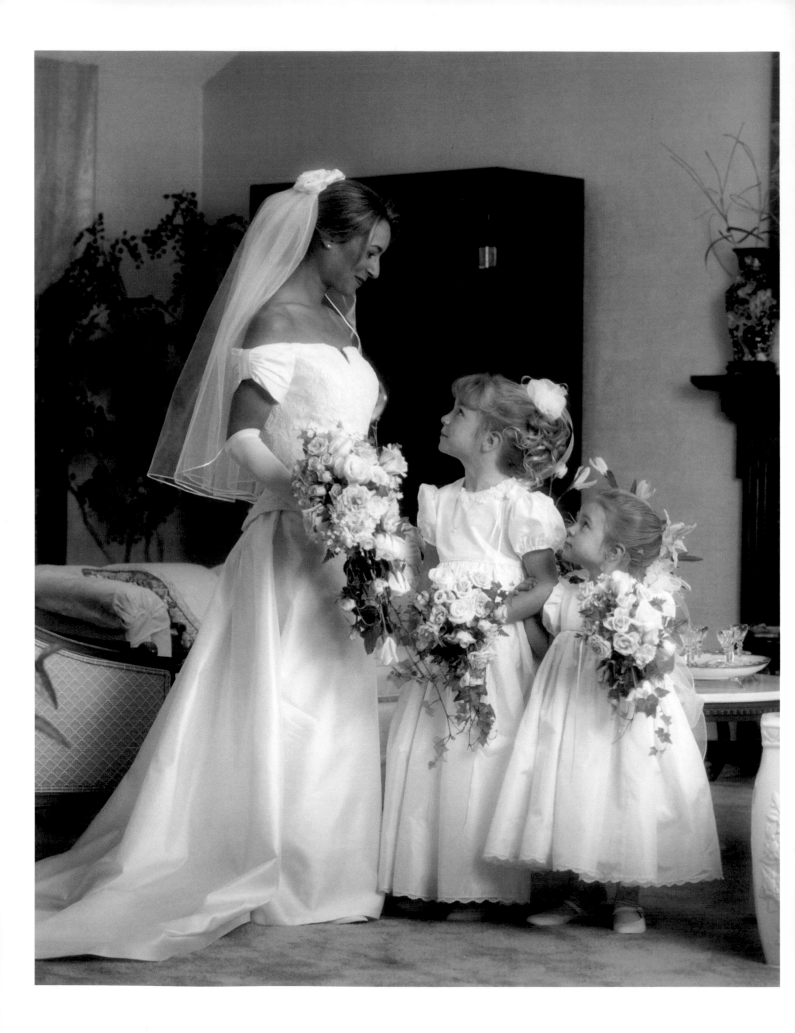

POSING

Most people prefer images where they look natural and like themselves. When a portrait includes more than one person, it's also nice to show the relationship between them or some kind of interaction. Here, a portrait of the bride and her flower girls was casually posed. As a result, the image is relaxed and the people look natural. This image is actually part of a series with several variations, including the subjects looking at the camera and the bride spontaneously leaning in for a hug.

LIGHTING RELATIONSHIPS

f/8.5— main light

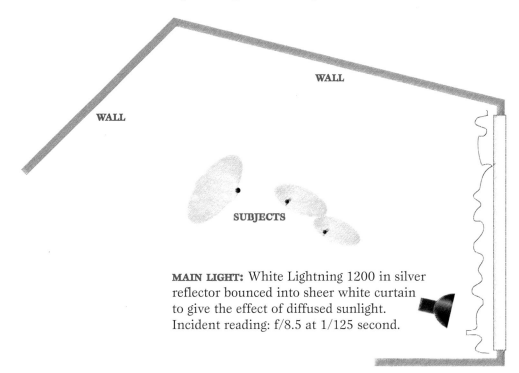

WALL

WALL

SUBJECTS

**MAIN LIGHT:** White Lightning 1200 in silver reflector bounced into sheer white curtain to give the effect of diffused sunlight. Incident reading: f/8.5 at 1/125 second.

**CAMERA:** Hasselblad 500CM with 150mm lens. **APERTURE:** f/11. **SHUTTER SPEED:** 1/125 second. **FILM:** Kodak PRN ISO 100.

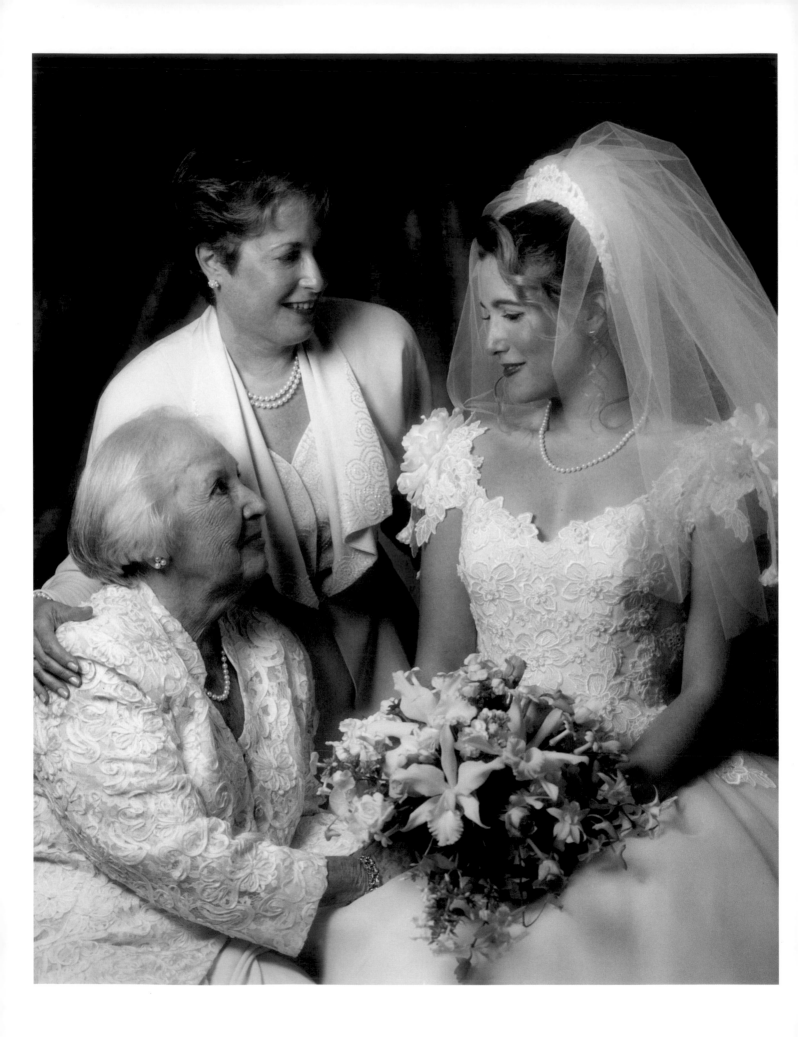

SETTING

This image is one in a series of portraits taken with the same setup (see page 67 for another portrait from this session). In this grouping, the bride was posed with her mother and grandmother. Having all the women look at each other created an intimate look. For a simple variation, you could have the subjects face the camera.

LIGHTING RELATIONSHIPS

f/5.6.5— background light (-1.5 stops)

f/11.0— main light

**WINDOW**

**MUSLIN BACKDROP**

**BACKGROUND LIGHT:** Lumedyne with blue gel. Reflected reading: f/5.6.5.

**SUBJECTS**

**REFLECTOR:** Larson 24" x 24" silver tipped to fill in the shadows cast by the mother and grandmother. Reflected reading: f/5.6.5.

**MAIN LIGHT:** White Lightning 1200 in 24" x 24" Apollo recessed soft box. Incident reading: f/11.

**CAMERA:** Hasselblad 500CM with 150mm lens. **APERTURE:** f/11. **SHUTTER SPEED:** 1/250 second. **FILM:** Kodak PRN ISO 100.

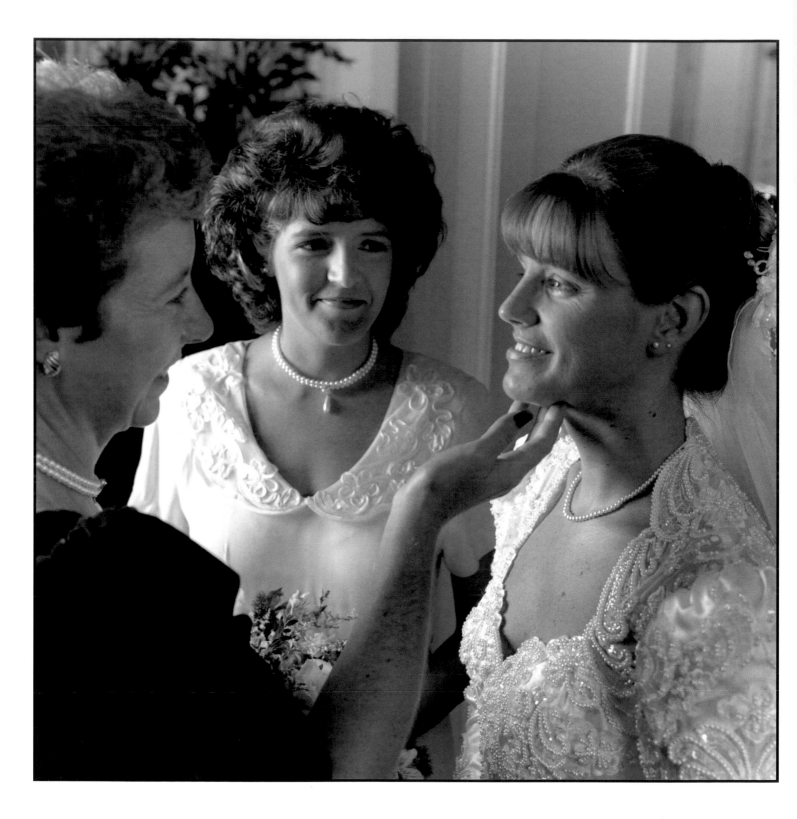

CAMERA ANGLE

For this portrait, the camera angle is level with the subject's heads.

LIGHTING

Since the bride's face is the focal point of the image, I metered off her skin to ensure correct exposure. Note that the mother's face and body act as a gobo in this setup, preventing light from the soft box from hitting the lens. The reflector lightens the shadows.

> LIGHTING RELATIONSHIPS
>
> **f/8.5—  main light**

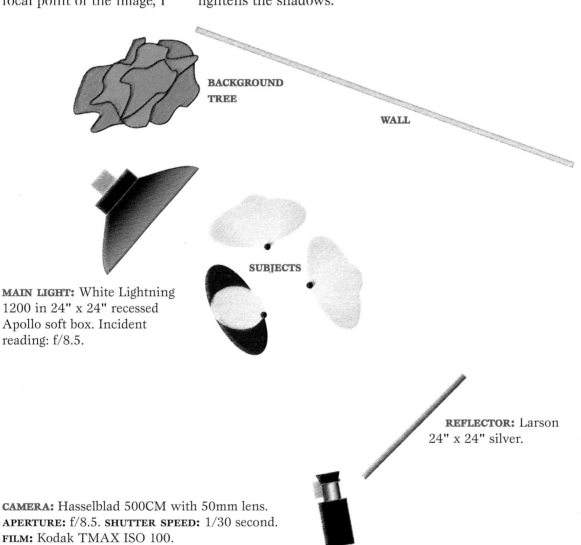

**BACKGROUND TREE**

**WALL**

**SUBJECTS**

**MAIN LIGHT:** White Lightning 1200 in 24" x 24" recessed Apollo soft box. Incident reading: f/8.5.

**REFLECTOR:** Larson 24" x 24" silver.

**CAMERA:** Hasselblad 500CM with 50mm lens. **APERTURE:** f/8.5. **SHUTTER SPEED:** 1/30 second. **FILM:** Kodak TMAX ISO 100.

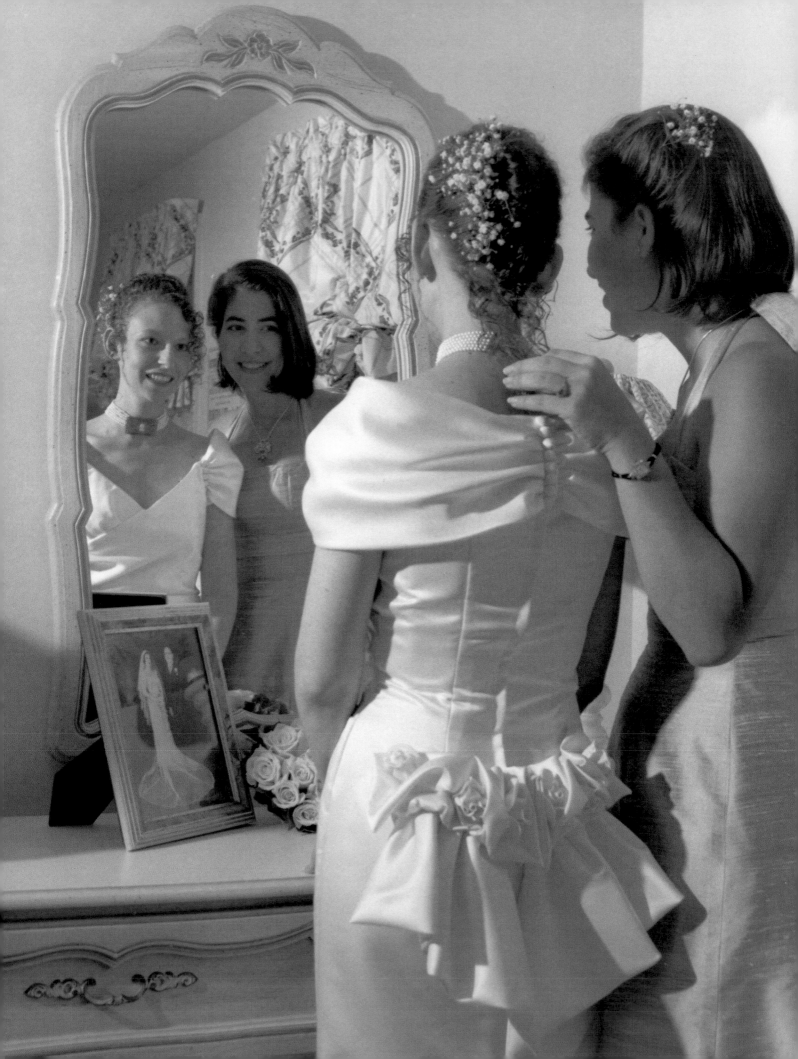

LIGHTING

For this candid-style mirror shot, the main light was placed to the side of the setup. Because it skims across the subjects, it reveals the texture on the subjects and their dresses. It also adds a sense of dimension. The fill light was placed behind the subjects, opening up the shadows on the subjects' backs, and bouncing back onto their faces from the mirror and light-colored wall.

FOCUS

The lens was focused on the subjects' reflection in the mirror, not on the subjects themselves.

| LIGHTING RELATIONSHIPS | |
|---|---|
| f/8.0— | fill light (-1 stop) |
| f/11.0— | main light |

**MIRROR**

**MAIN LIGHT:** Lumedyne with silver parabolic reflector on monopod. Incident reading at subject: f/11.

**SUBJECTS**

**FILL LIGHT:** On-camera Lumedyne flash in 18" x 18" self-made foam-core soft box covered with draftman's vellum to diffuse light. Incident reading taken at subject (not mirror): f/8.

**CAMERA:** Hasselblad 500CM with 50mm lens. **APERTURE:** f/11. **SHUTTER SPEED:** 1/30 second. **FILM:** Kodak TMAX ISO 100.

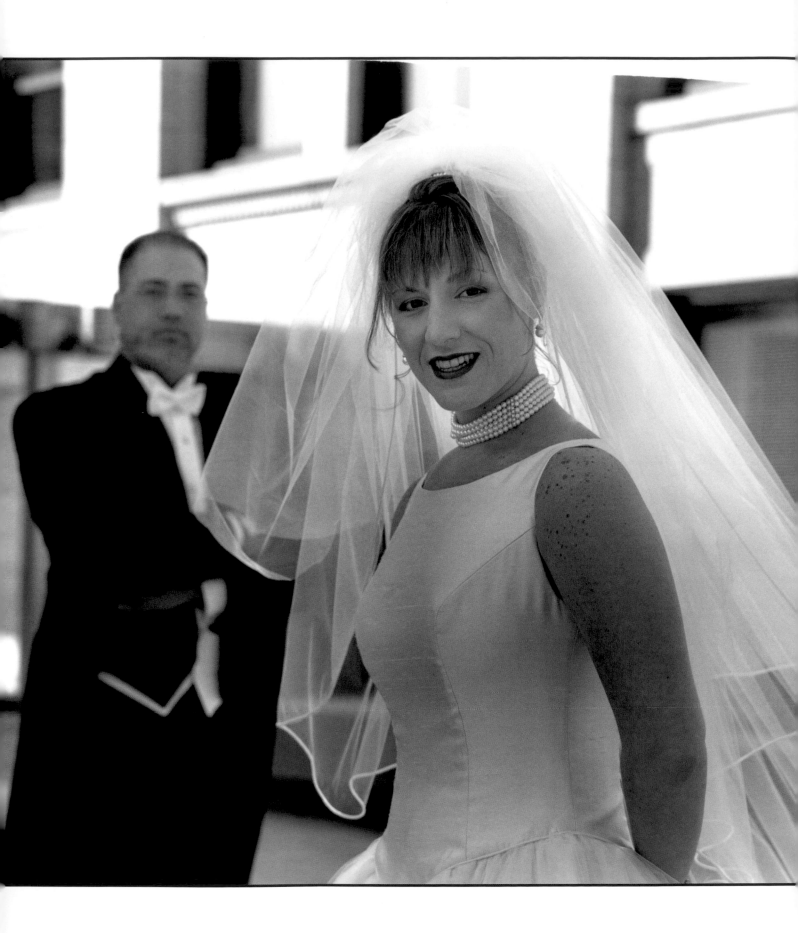

DEPTH OF FIELD

Selective focus, controlled depth of field to emphasize a particular subject in the frame, was used to draw attention to the bride. While she is the real subject of the portrait, the groom in the background is still recognizable. The background is even more out of focus, helping to minimize distractions in this area. The architectural lines are still visible, however, and remain an important element in framing the composition.

---

LIGHTING RELATIONSHIPS

**f/5.6—** **main light**

f/22.0— **background**
**(+4 stops)**

---

**MAIN LIGHT:** Open sky and reflector combined give incident reading at subjects (f/5.6).

**BUILDING**

**SUBJECT**

**BUILDING**

**SUBJECT**

**REFLECTOR:** Larson 24" x 24" silver.

**CAMERA:** Hasselblad 500CM with 150mm lens. **APERTURE:** f/5.6. **SHUTTER SPEED:** 1/125 second. **FILM:** Kodak CN 400.

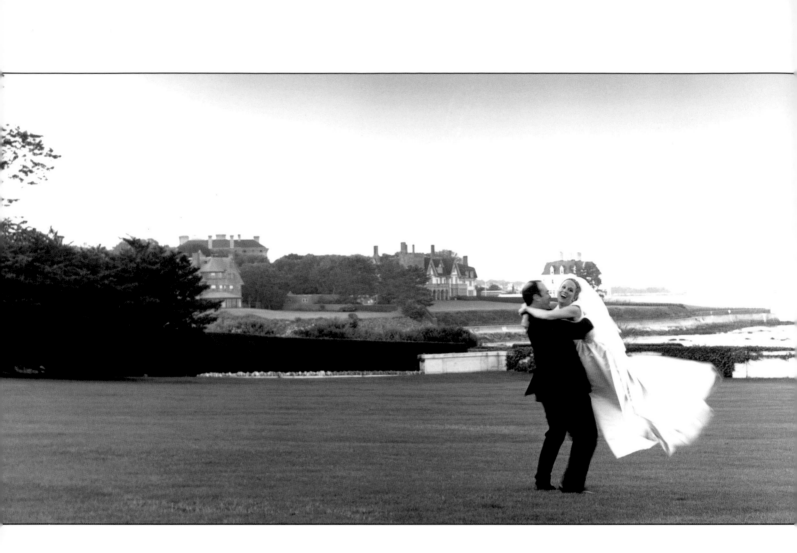

LIGHTING

This action portrait was taken under the open sky at sunset. This meant we had nice, even, area lighting—ideal for photographing subjects in motion. If there is any problem with this kind of lighting, it is that the lack of directional quality in the light can make textures less apparent and reduce the sense of dimension. Here, however, a large pine tree to the left of the camera acted as a gobo. By subtracting light from one side of the subjects, this helped to create a more directional lighting effect.

SHUTTER SPEED

Using a slow shutter speed was required to make the motion visible. To minimize camera movement with this longer exposure, I shot the image from a tripod with a cable release.

---

LIGHTING RELATIONSHIPS

f/8.0—  main light
(open sky at
sunset)

---

**SUBJECTS**

**GOBO:** Large pine tree.

**MAIN LIGHT:** Open sky at sunset. Incident reading: f/8 at 1/15 second.

**CAMERA:** Hasselblad 500CM with 150mm lens on Bogen tripod with cable release. **APERTURE:** f/8. **SHUTTER SPEED:** 1/15 second. **FILM:** Kodak CN 400.

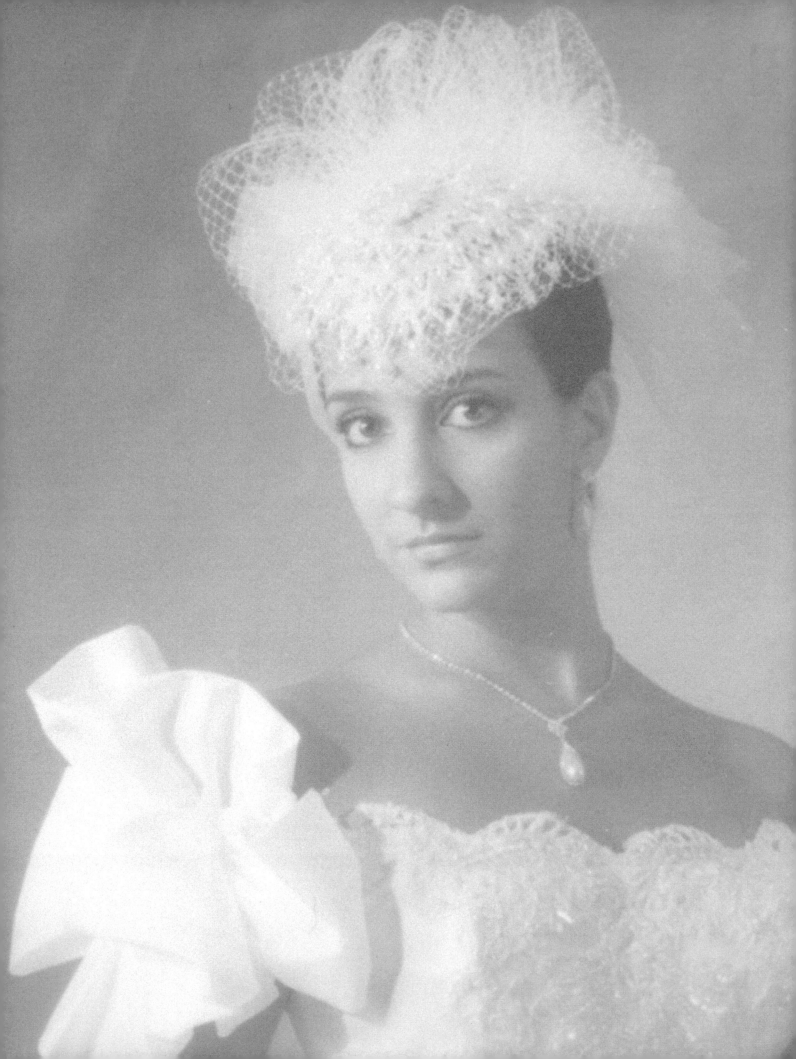

# 8

# SPECIAL
# LIGHTING
# EFFECTS:

## TECHNIQUES
## AND IMAGES

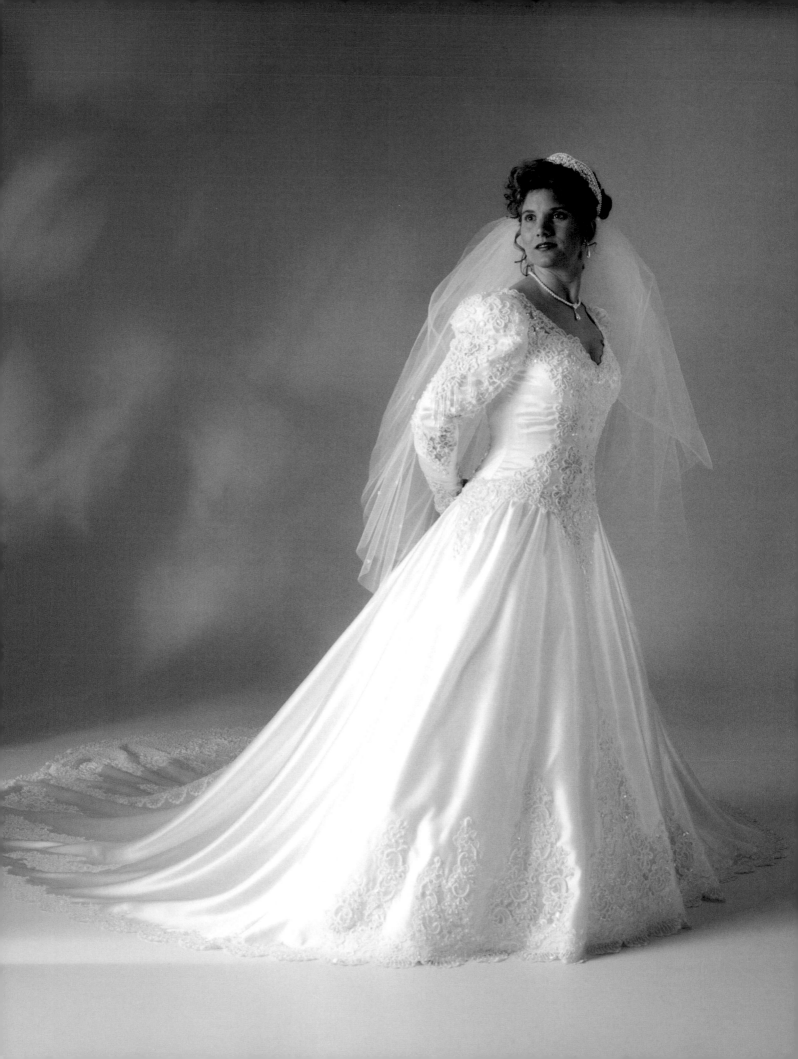

LIGHTING

Creating a mottled background effect is quite simple and can make a plain paper backdrop look more like a painted canvas. Here, the effect is accomplished by filtering the light from a bare bulb strobe through the leaves of a plant. A harder light source like this works well because it casts more hard-edged, well-defined shadows. Using a modeling light is very useful, because it allows the effect to be previewed accurately to ensure a pleasing result.

**BACKDROP**

**PLANT**

**BACKGROUND LIGHT:** Lumedyne bare bulb strobe with modeling light on. Placed vertically. Reflected reading on highlights of the background: f/11.

**GOBO**

**SUBJECT**

**REFLECTOR:** 36" x 48" Photogenic silver reflector.

**MAIN LIGHT:** White Lightning 1200 in 36" x 48" recessed Chimera soft box. Incident reading: f/11.5.

**CAMERA:** Mamiya RZ67 with 90mm lens. **APERTURE:** f/11. **SHUTTER SPEED:** 1/30 second. **FILM:** Kodak PRN 100.

LIGHTING RELATIONSHIPS

**f/11.5—  main light**

f/11.0—  background light (-.5 stop)

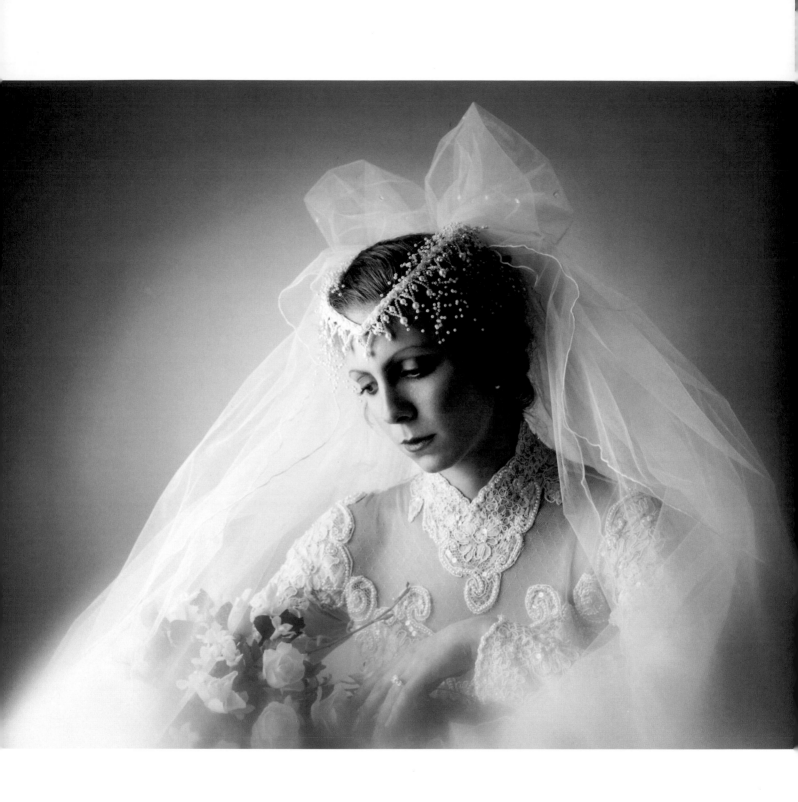

LIGHTING

The background light was placed very close to the background, preventing light from striking the outer edges of the background. This resulted in a custom "burned-in" look, with dark edges surrounding the bride.

DIFFUSION

A 4" x 4" piece of glass with petroleum jelly smeared at the bottom was placed in the front slot of the Lindahl shade. This resulted in the soft and dreamy look at the bottom edge of the portrait.

| LIGHTING RELATIONSHIPS | |
| --- | --- |
| f/11.5— | hair light (-.5 stop) |
| f/11.5— | background light (-.5 stop) |
| f/16— | **main light** |

**BACKDROP**

**BACKGROUND LIGHT:** Photogenic Flashmaster AA01. Reflected reading of background at shoulder height: f/11.5. Reflected reading of background at corners: f/5.6.5.

**SUBJECT AT POSING TABLE**

**HAIR LIGHT:** Photogenic flashmaster AA01 on boom, projected through an amber gel. Set half a stop below main light for a soft effect—just enough to highlight the bride's red hair. This light also adds the overall warm cast to the image. Incident reading: f/11.5.

**MAIN LIGHT:** Photogenic Flashmaster at 200 watts encased in three 4' x 6' panels supported by PVC framing. Light is projected through white rip stop nylon on the front and goboed on the sides by black rip stop nylon. Incident reading: f/16.

**CAMERA:** Mamiya RZ67 with 250mm lens and Lindahl Compendium shade. **APERTURE:** f/16. **SHUTTER SPEED:** 1/30 second. **FILM:** Kodak VPS rated at ISO 80.

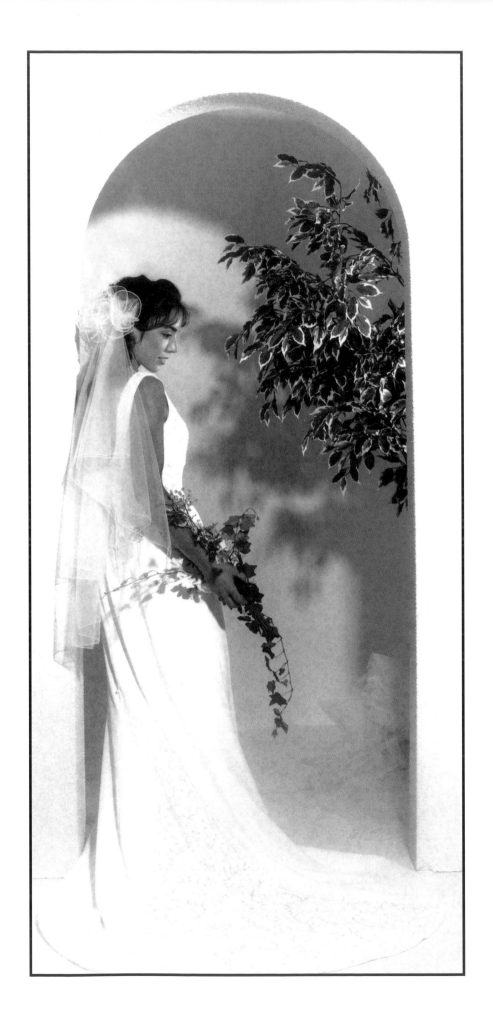

SIMPLE SCENES

The combination of a white wall and an archway is a very simple scene—but also a very flexible one. Here, for example, props and lighting techniques have been combined to create a more complex effect. For the portrait, I added a ficus tree and lit the scene so that it would cast well-defined shadows on the background. This relatively hard light also creates an overall dramatic look.

LIGHTING RELATIONSHIPS

f/8.0—  fill light
        (-1.5 stop)

f/11.5—  main light

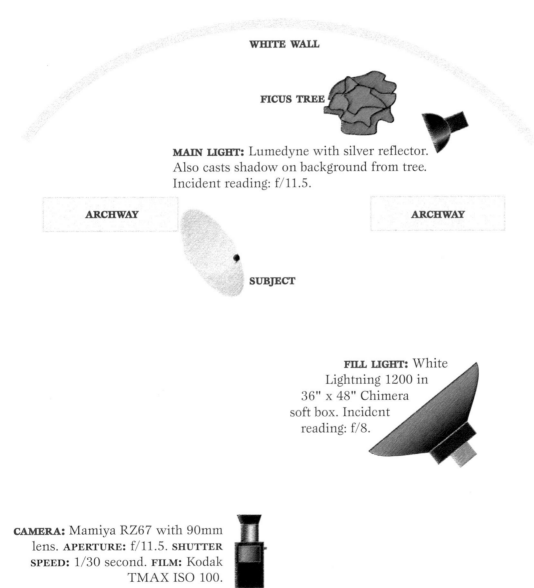

**WHITE WALL**

**FICUS TREE**

**MAIN LIGHT:** Lumedyne with silver reflector. Also casts shadow on background from tree. Incident reading: f/11.5.

**ARCHWAY**

**ARCHWAY**

**SUBJECT**

**FILL LIGHT:** White Lightning 1200 in 36" x 48" Chimera soft box. Incident reading: f/8.

**CAMERA:** Mamiya RZ67 with 90mm lens. **APERTURE:** f/11.5. **SHUTTER SPEED:** 1/30 second. **FILM:** Kodak TMAX ISO 100.

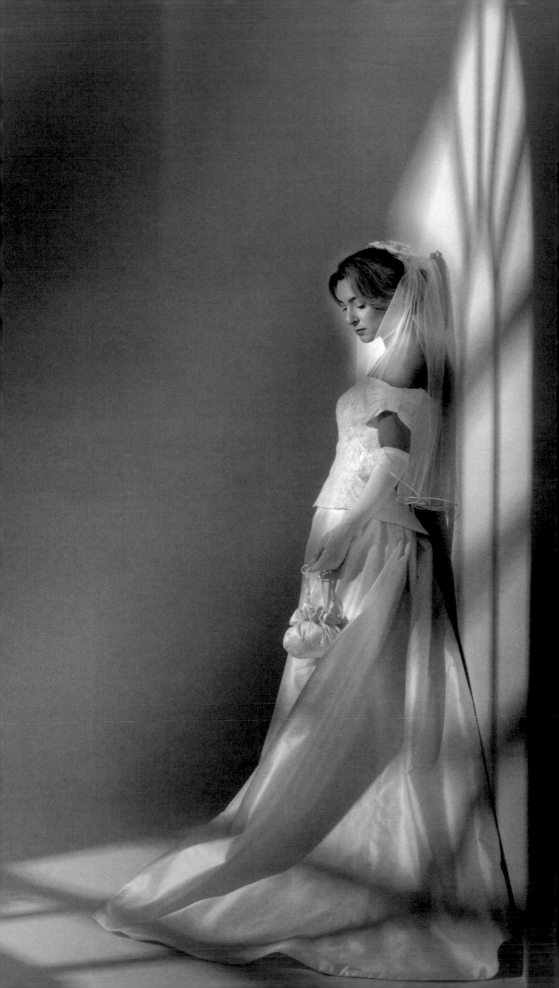

SHADOWS

The shadow pattern in this bridal portrait was created by shining the bare bulb main light through a trellis. Special care had to be taken to ensure that lines did not fall on the bride's face. The fill light was set much lower than the main light to ensure that the shadows remained defined.

---

LIGHTING RELATIONSHIPS

f/5.6.5—    fill light
            (-2.5 stops)

f/16.0—    main light

---

TRELLIS

SUBJECT

**MAIN LIGHT:** White Lightning 1200 bare bulb strobe placed horizontally and aimed toward the subject. Incident reading: f/16.

**CAMERA:** Mamiya RZ67 with 90mm lens. **APERTURE:** f/11.5. **SHUTTER SPEED:** 1/30 second. **FILM:** Kodak TMAX ISO 100.

**FILL LIGHT:** White Lightning 1200 in 36" x 48" Chimera soft box. Incident reading: f/5.6.5.

# CORRECTIVE TECHNIQUES

The goal of every portrait photographer should be to make his or her subjects look their very best. Often, this necessitates using corrective techniques to minimize the appearance of problem areas. The following solutions to some common problems have been provided by Anne Brignolo (M. Photog. Cr.) who operates Brignolo Studio in Bridgeport, CT.

| SUBJECT HAS: | CORRECTIVE POSING: | CORRECTIVE LIGHTING: |
| --- | --- | --- |
| Baldness | Lower camera position, blend top of head with backdrop | Use no hair light; use screen to shield top of head from light |
| Narrow chin | Tilt chin upward; raise camera position | |
| Angular nose | Minimize effect by turning face toward the lens | |
| Curved nose | | Light face from the bend side to create straighter appearance |
| Long nose | Tilt chin upward; lower camera position; face directly toward lens; use longer lens | Lower main light to reduce shadow cast |
| Small eyes | Have subject look above lens; raise camera position | Lower main light |

| SUBJECT HAS: | CORRECTIVE POSING: | CORRECTIVE LIGHTING: |
|---|---|---|
| Broad face | Turn face to three-quarter position | Use short lighting |
| Narrow face | | Use broad lighting; lower main light |
| Double chin | Extend back of neck and bring chin forward; raise camera position | Raise main light |
| Wrinkled skin | Use three-quarter pose with diffusing filter | Use larger/closer main light; use diffused lighting |
| Facial defects | Keep problem area on shadow side | |
| Prominent ears | Hide far ear behind head and keep near ear in shadow, consider profile | |
| Wearing glasses | Tilt lenses down by raising bows slightly; raise or lower the chin slightly; take out lenses; use duplicate frames without lenses | Use fill light laterally; use very large light source placed very close to face |
| Protruding eyes | Have subject look downward | |
| Heavyset figure | Use dark clothes and dark background (blend tonality of clothes into background); use V-necks, colors and jewelry to draw attention away from face | Use short lighting |

# GLOSSARY

**Accent Light**—The kicker or accent light is a light that skims the highlight side of the subject and creates additional roundness and range of tone.

**Background Light**—This light illuminates the background in a portrait.

**Corrective Lighting**—Lighting that is designed to disguise a perceived flaw in the subject's appearance.

**Corrective Posing**—Posing that is designed to disguise a perceived flaw in the subject's appearance.

**Exposure Latitude**—The range of exposure from highlight to shadow in which detail is captured on film (the highlight areas have detail in the whites and the shadow areas have detail in the blacks).

**Fill Light**—The fill light is used to lighten the shadows created by the main light and add to the roundness of the subject's appearance. This is a flat light placed behind the camera. It provides no direction of light and casts no shadow.

**Form Fill Light**—This is a light that follows the nose, lighting only the mask of the face.

**Gel**—A transparent colored material placed over a light to change its color.

**Gobo**—A device used to block light to prevent it from hitting the camera lens or an area of the scene.

**Hair Light**—This light, placed over the subject, illuminates the hair and adds texture to it. It also separates the hair from the background.

**Incident Light Metering**—A reading of the light falling upon the subject.

**Kicker Light**—*See* Accent Light.

**Lens Shade**—An accessory added to the front of a lens to reduce unwanted light from entering the lens. May also be used to hold filters and vignetters in place in front of the lens.

**Light Direction**—Where the light is coming from.

**Light Intensity**—The amount of light, measured in f-stops.

**Light Quality**—Determined by the fixture that creates the light. The larger and closer to the subject the source is, the more diffused it will be. The smaller and more distant from the subject the source is, the more specularity will show in the highlights.

**Light Ratio**—The difference (measured in f-stops) between the light falling on the highlight side of the subject and the light falling on the shadow side of the subject. Usually noted as a proportion, such a 2:1 (twice as much light on the highlight as on the shadow) or 3:1 (three times as much light on the highlight as on the shadow).

**Main Light**—This light shows contrast, roundness and direction on the subject. The camera's aperture is based on this light.

**Previsualization**—The creative process of determining the desired look of a portrait and how to achieve it.

**Reflective Light Metering**—Reading of light reflected off the subject. This is an averaged reading and to be accurate and consistent, must be taken by measuring the light reflected from an 18% gray card. (Generally, the only time I use this type of meter reading is when measuring the light reflected from the background.)

**Separation Light**—The sole purpose of this light is to illuminate the back of the hair, veil or dress, creating a halo effect or separating the subject from the background. It differs slightly from the background light because it is aimed at the subject rather than the background.

**Specularity**—Areas of very bright highlight. This is a common problem in areas of the face with increased reflectivity (the bridge of the nose, the forehead, the chin and the cheeks).

**Through the Lens Metering (TTL)**—*See* Reflective Light Metering.

**Vue Meter Numbers**—A densitometer reading that measures the density of a negative when the film is analyzed.

# INDEX

# Other Books from
# Amherst Media™

## Wedding Photographer's Handbook

*Robert and Sheila Hurth*

A complete step-by-step guide to succeeding in the world of wedding photography. Packed with shooting tips, equipment lists, must-get photo lists, business strategies, and much more! $29.95 list, 8½x11, 176p, index, 100 b&w and color photos, diagrams, order no. 1485.

## Lighting for People Photography 2nd Edition

*Stephen Crain*

The up-to-date guide to lighting. Includes: set-ups, equipment information, strobe and natural lighting, and much more! Features diagrams, illustrations, and exercises for practicing the techniques discussed in each chapter. $29.95 list, 8½x11, 120p, 80 b&w and color photos, glossary, index, order no. 1296.

## Wedding Photography:
### Creative Techniques for Lighting and Posing, 2nd Edition

*Rick Ferro*

Creative techniques for lighting and posing wedding portraits that will set your work apart from the competition. Covers every phase of wedding photography. $29.95 list, 8½x11, 128p, full color photos, index, order no. 1649.

## Lighting Techniques for Photographers

*Norman Kerr*

This book teaches you to predict the effects of light in the final image. It covers the interplay of light qualities, as well as color compensation and manipulation of light and shadow. $29.95 list, 8½x11, 120p, 150+ color and b&w photos, index, order no. 1564.

## Profitable Portrait Photography

*Roger Berg*

A step-by-step guide to making money in portrait photography. Combines information on portrait photography with detailed business plans to form a comprehensive manual for starting or improving your business. $29.95 list, 8½x11, 104p, 100 photos, index, order no. 1570

## Professional Secrets for Photographing Children

*Douglas Allen Box*

Covers every aspect of photographing children on location and in the studio. Prepare children and parents for the shoot, select the right clothes capture a child's personality, and shoot story book themes. $29.95 list, 8½x11, 128p, 74 photos, index, order no. 1635.

## Family Portrait Photography

*Helen Boursier*

Learn from professionals how to operate a successful portrait studio. Includes: marketing family portraits, advertising, working with clients, posing, lighting, and selection of equipment. Includes images from a variety of top portrait shooters. $29.95 list, 8½x11, 120p, 123 photos, index, order no. 1629.

## Wedding Photojournalism

*Andy Marcus*

Learn the art of creating dramatic unposed wedding portraits. Working through the wedding from start to finish you'll learn where to be, what to look for and how to capture it on film. A hot technique for contemporary wedding albums! $29.95 list, 8½x11, 128p, b&w, over 50 photos, order no. 1656.

## Professional Secrets of Wedding Photography

*Douglas Allen Box*

Over fifty top-quality portraits are individually analyzed to teach you the art of professional wedding portraiture. Lighting diagrams, posing information and technical specs are included for every image. $29.95 list, 8½x11, 128p, order no. 1658.

## Photo Retouching with Adobe® Photoshop®

*Gwen Lute*

Designed for photographers, this manual teaches every phase of the process, from scanning to final output. Learn to restore damaged photos, correct imperfections, create realistic composite images and correct for dazzling color. $29.95 list, 8½x11, 120p, 60+ photos, order no. 1660.

## Storytelling Wedding Photography

*Barbara Box*

Barbara and her husband shoot as a team at weddings. Here, she shows you how to create outstanding candids (which are her specialty), and combine them with formal portraits (her husband's specialty) to create a unique wedding album. $29.95 list, 8½x11, 128p, 60 b&w photos, order no. 1667.

## Fine Art Children's Photography

*Doris Carol Doyle and Ian Doyle*

Learn to create fine art portraits of children in black & white. Included is information on: posing, lighting for studio portraits, shooting on location, clothing selection, working with kids and parents, and much more! $29.95 list, 8½x11, 128p, 60 photos, order no. 1668.

## Infrared Portrait Photography

*Richard Beitzel*

Discover the unique beauty of infrared portraits, and learn to create them yourself. Included is information on: shooting with infrared, selecting subjects and settings, filtration, lighting, and much more! $29.95 list, 8½x11, 128p, 60 b&w photos, order no. 1669.

## Marketing and Selling Black & White Portrait Photography

*Helen T. Boursier*

A complete manual for adding b&w portraits to the products you offer clients (or offering exclusively b&w photography). Learn how to attract clients and deliver the portraits that will keep them coming back. $29.95 list, 8½x11, 128p, 50+ photos, order no. 1677.

## Innovative Techniques for Wedding Photography

*David Neil Arndt*

Spice up your wedding photography (and attract new clients) with dozens of creative techniques from top-notch professional wedding photographers! $29.95 list, 8½x11, 120p, 60 photos, order no. 1684.

## Infrared Wedding Photography

*Patrick Rice, Barbara Rice & Travis HIll*

Step-by-step techniques for adding the dreamy look of black & white infrared to your wedding portraiture. Capture the fantasy of the wedding with unique ethereal portraits your clients will love! $29.95 list, 8½x11, 128p, 60 images, order no. 1681.

## Photographing Children in Black & White

*Helen T. Boursier*

Learn the techniques professionals use to capture classic portraits of children (of all ages) in black & white. Discover posing, shooting, lighting and marketing techniques for black & white portraiture in the studio or on location. $29.95 list, 8½x11, 128p, 100 photos, order no. 1676.

## Dramatic Black & White Photography

SHOOTING AND DARKROOM TECHNIQUES

*J.D. Hayward*

Create dramatic fine-art images and portraits with the master b&w techniques in this book. From outstanding lighting techniques to top-notch, creative darkroom work, this book takes b&w to the next level! $29.95 list, 8½x11, 128p, order no. 1687.

## Posing and Lighting Techniques for Studio Photographers

*J.J. Allen*

Master the skills you need to create beautiful lighting for portraits of any subject. Posing techniques for flattering, classic images help turn every portrait into a work of art. $29.95 list, 8½x11, 120p, 125 fullcolor photos, order no. 1697.

## Studio Portrait Photography in Black & White

*David Derex*

From concept to presentation, you'll learn how to select clothes, create beautiful lighting, prop and pose top-quality black & white portraits in the studio. $29.95 list, 8½x11, 128p, 70 photos, order no. 1689.

## Corrective Lighting and Posing Techniques for Portrait Photographers

*Jeff Smith*

Learn to make every client look his or her best by using lighting and posing to conceal real or imagined flaws – from baldness, to acne, to figure flaws. $29.95 list, 8½x11, 120p, full color, 150 photos, order no. 1711.

## Make-Up Techniques for Photography

*Cliff Hollenbeck*

Step-by-step text paired with photographic illustrations teach you the art of photographic make-up. Learn to make every portrait subject look his or her best with great styling techniques for black & white or color photography. $29.95 list, 8½x11, 120p, 80 full color photos, order no. 1704.

## Professional Secrets of Natural Light Portrait Photography

*Douglas Allen Box*

Learn to utilize natural light to create inexpensive and hassel-free portraiture. Beautifully illustrated with detailed instructions on equipment, setting selection and posing. $29.95 list, 8½x11, 128p, 80 full color photos, order no. 1706.

## Portrait Photographer's Handbook

*Bill Hurter*

Bill Hurter has compiled a step-by-step guide to portraiture that easily leads the reader through all phases of portrait photography. This book will be an asset to experienced photographers and beginners alike. $29.95 list, 8½x11, 128p, full color, 60 photos, order no. 1708.

## Professional Marketing & Selling Techniques for Wedding Photographers

*Jeff Hawkins and Kathleen Hawkins*

Learn the business of successful wedding photography. Includes consultations, direct mail, print advertising, internet marketing and much more. $29.95 list, 8½x11, 128p, 80 photos, order no. 1712.

## Traditional Photographic Effects with Adobe Photoshop

*Michelle Perkins and Paul Grant*

Use Photoshop to enhance your photos with handcoloring, vignettes, soft focus and much more. Every technique contains step-by-step instructions for easy learning. $29.95 list, 8½x11, 128p, 150 photos, order no. 1721.

## Master Posing Guide for Portrait Photographers

*J. D. Wacker*

Learn the techniques you need to pose single portrait subjects, couples and groups for studio or location portraits. Includes techniques for photographing weddings, teams, children, special events and much more. $29.95 list, 8½x11, 128p, 80 photos, order no. 1722.

# More Photo Books Are Available

## Contact us for a FREE catalog:
### AMHERST MEDIA
### PO BOX 586
### AMHERST, NY 14226 USA

### www.AmherstMedia.com